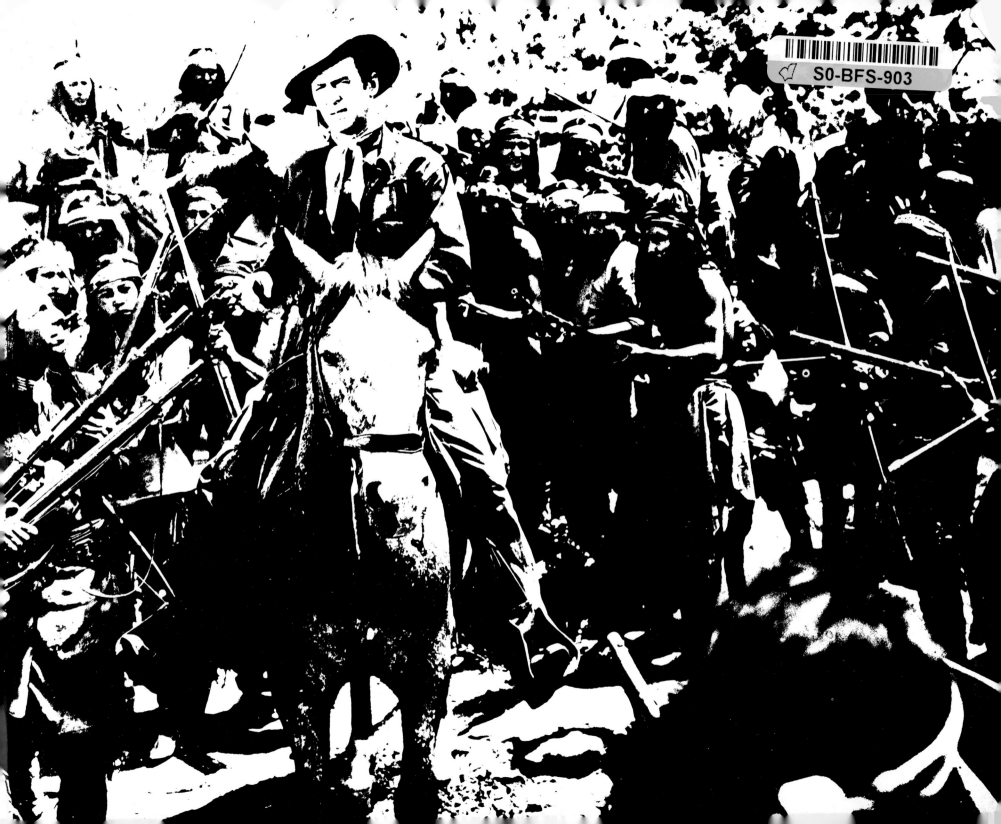

THE HOLLYWOOD INDIAN
Stereotypes of Native Americans in Films

John E. O'Connor

Foreword by Lorraine E. Williams

Published by the New Jersey State Museum

 Publication of this book has been made possible by a grant from the New Jersey Committee for the Humanities through the National Endowment for the Humanities.

Catalog design supported by Friends of the New Jersey State Museum

Director's Statement

The New Jersey State Museum, with its definitive New Jersey Indian archaeological, ethnological and archival collections, is recognized as the State's primary resource for research on prehistoric and historic Native American groups who have lived in the State. The Museum is also concerned with contemporary issues affecting Native Americans. *The Hollywood Indian: Stereotypes of Native Americans in Films*—a project which includes an exhibit and related publication, a symposium and a film series—explores society's perceptions of Native Americans as influenced by movies.

The project grew out of the Museum's archaeology/ethnology education program where it became increasingly evident that to teach about Indians one must frequently "unteach" the impressions left by movies and television. While this project deals with Native American stereotypes, its message has broader application. As we become a society which relies more and more on electronic media for knowledge, we must exercise care in "believing" the images portrayed. As this project shows, screen images frequently reflect dramatic and other concerns more than they do historic and cultural accuracy.

Generously supported by a grant from the New Jersey Committee for the Humanities through the National Endowment for the Humanities, the project was originated and coordinated by Lorraine E. Williams, the Museum's Curator of Archaeology/Ethnology. Professor John E. O'Connor of the New Jersey Institute of Technology History Department researched the films which formed the basis for the project. Joanna Cohan Scherer of the Smithsonian Institution researched documentary photographs. The symposium on November 22, 1980, featured Dr. O'Connor; Professor Matthew Baigell, Rutgers University Art Department; George Abrams, Director of the Seneca-Iroquois National Museum, Salamanca, New York; and Jamake Highwater, author and Native American consultant to the New York State Council on the Arts. Museum Curator of Education Raymond Howe assisted in scheduling the appropriate films which demonstrate the issues examined by this project. In addition, Dr. Williams supervised the production of this handsome volume, designed by Rose Marie Bratek, which goes far beyond an exhibition catalog and becomes a major resource for film and cultural historians, anthropologists, Native Americans and the general public. Everyone who worked on the project is to be thanked and congratulated for an outstanding contribution to our knowledge of Native Americans and the role of media in influencing our view of various cultures.

I wish to extend special thanks to staff members of the Academy of Motion Picture Arts and Sciences Research Library; American Film Institute; Museum of Modern Art; Performing Arts Research Collection, New York City Public Library at Lincoln Center; Twentieth Century-Fox, Story Department Archives and University of Southern California Research Library, Special Collections for permitting the consultants to make extensive use of their resources; the lenders for permitting use of their collections in the exhibition; and the New Jersey Committee for the Humanities for recognizing the importance of this project and supporting it wholeheartedly.

Design: Rose Marie Bratek

Editing: Peggy K. Lewis
 Allen Hilborn

Photography: Joseph Crilley
 Karen Flinn

Documentary photo research: Joanna Cohan Scherer

Photographs/illustrations:
 American Museum of Natural History
 Donald Baird
 Buffalo Bill Historical Center
 Carlos Clarens
 Thomas Gilcrease Institute of American History and
 Art
 Killiam Shows, Inc.
 Museum of Modern Art/Film Stills Archives
 National Anthropological Archives, Smithsonian
 Institution
 New Jersey State Museum/Photo Archives

Inside covers: scenes from *Broken Arrow* (1950)

Note: Italicized portions of picture captions are by Lorraine E. Williams

Contents

Most children are exposed to movies and television long before they can read or go to school. Their attitudes toward and opinions about the Native Americans have been well established by the mass media long before they begin their schooling. It cannot be emphasized enough that Native American children are faced with exactly the same problem. Remember —the only real Indian is a Hollywood Indian.
(Friar and Friar 1972:224)

Foreword

Ask a child of ten to draw a picture of an Indian, and the result is usually a character of reddish complexion wearing a trailing feathered bonnet, loincloth and body paint. Adults are not normally asked to perform such a task, but one wonders if the result would be all that different. Stereotypes are certainly not limited to children's world views. In lessons on New Jersey's Delaware Indians presented at the Museum, not only fourth graders but also sometimes their teachers assure our staff that the Delaware, an Eastern Woodlands Indian group, lived in tepees, wore feather bonnets and hunted buffalo. It is not difficult to trace the source of such information: what all are describing is "the American Indian"—a stereotype perpetuated by the film industry and television.

We draw much of what we "learn" as adults from the popular films and television programs we view. The ethnic stereotypes portrayed profoundly influence our attitudes toward people in our society and other societies. Since motion pictures (or the "movies") began with Thomas Alva Edison's Kinetoscope in 1889, they have provided entertainment, be it craft or art, to millions of people throughout the world. What is less frequently recognized is that the movies have also been a powerful medium for the dissemination of knowledge. Much of what we know of things exotic (i.e., matters of which we have no first-hand experience) we owe to the films we have seen. One area of the exotic that has become a worldwide commonplace through the agency of the movies is the popular image of the American Indian.

Native American populations of North America were culturally extremely diverse. They comprised hundreds of distinct groups with different languages, ways of securing food, house styles, and social political organizations. The popular media presentations blur these cultural distinctions. The feather-bonneted figure approximates most closely the Plains Indians and their nineteenth century lifestyle. Having acquired horses European explorers and colonists introduced to North America beginning in the sixteenth century, by the 1800s the Plains Indians had developed into nomadic buffalo hunters. Their trailing eagle-feather bonnets and roughly-conical buffalo hide covered tepees are also part of the popular image, one John C. Ewers (1964) has noted that the movie industry did not create.

In his study "The Emergence of the Plains Indian as the Symbol of the North American Indian" Ewers focuses on four contributing factors—the arts, popular literature, news coverage and Wild West Shows. The Plains Indians were the most popular subjects for well-known nineteenth and early twentieth century artists George Catlin, Charles Schreyvogel, Frederic Remington and Charles Russell. Remington's sketches also appeared in the widely-circulated *Harper's Weekly*, as did those of reporter-artist Theodore R. Davis after he had shifted from Civil War coverage to battlefield accounts of the Plains Indians' wars. During the second half of the nineteenth century, dime novels steadily increased in popularity. Their plots commonly involved Plains Indians in conflict with the U.S. military, settlers, frontiersmen or all three.

The major premovies medium disseminating the Plains Indian stereotype, however, was undoubtedly the Wild West Show. The artist George Catlin organized the first recorded show as early as the 1830s and toured in the U.S. and in western Europe. The best-known and most widely-traveled of these shows opened in 1883 as Buffalo Bill's Wild West Show. It continued for more than thirty years, employing mostly members of the Dakota (Sioux) tribes and including even Sitting Bull during the 1885 season.

Also contributing to the stereotypes of the American Indians was attention attracted by the Indian wars of 1860-90 on the Central Plains and in the Southwest. By this period, when the Plains tribes and the southwestern Apache were in conflict with the U.S. government, the press coverage was more de-

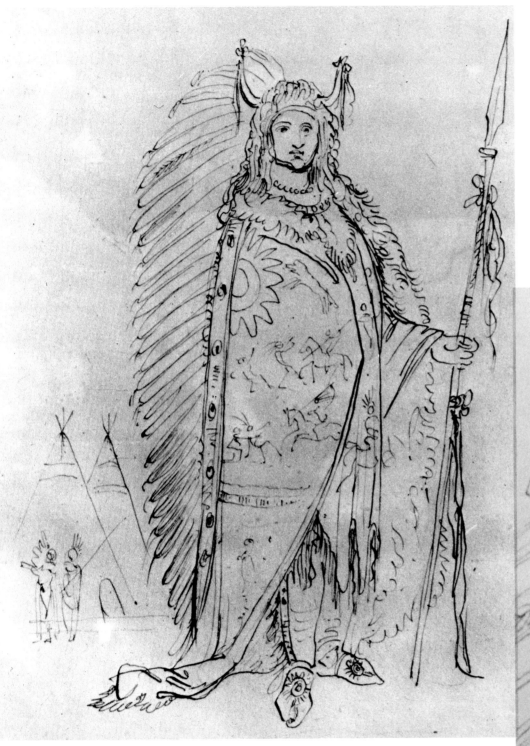

Ee-ah-sa-pa War Chief of
Nee-caw-wee-gees Sioux (Dah-co-ta),
A Page From the Sketchbook
of George Catlin
Courtesy of The Thomas Gilcrease Institute
of American History and Art, Tulsa, Oklahoma

Frederic Remington, *The Cheyenne*, 1901.
Bronze, Cast No. 9
Courtesy Buffalo Bill Historical Center,
Cody, Wyoming

tailed and intensive. The bloodthirsty savage stereotype of the movie Indian can be traced to the fact that much of the non-Indian public during the latter part of the nineteenth century viewed "the Indian" as the enemy; and the winners, even in those conflicts, wrote the history.

While U.S. military personnel and reporters have written a wealth of descriptions of the Indian wars, we have few accounts from the Indians' perspective. Only rarely was a Native American story transcribed (as in Geronimo's autobiography), and as rarely did pictographic records drawn by Native Americans on hides or in notebooks survive. Warfare, while an important aspect of nineteenth century history, does not represent the totality of Native American societies, even for those involved in the conflicts, much less for all the Native American societies of North America.

All of these factors had, by the 1890s, contributed to the popular image of the feather-bonneted horseman stereotyped in literature, art and Wild West Shows. It is not surprising that the new entertainment medium of films was quick to draw on this subject, given its proven crowd appeal, particularly as it was seen as part of the American western frontier, an area rich in legend and visual aesthetics. In 1910 alone, a hundred films depicting American Indians were released (Friar and Friar 1972:92). In 1911 the Bison Film Company began using Indians from the Miller Brothers 101 Ranch Wild West Show wintering in California (Balshofer and Miller 1967:76). Such use of Wild West Show Plains Indians reinforced the popular image that Hollywood had adopted from other media.

Many of the earliest films portraying Indians were actually made in New Jersey (Spehr 1977). As supposed Plains Indians wearing an occasional southwestern Navajo blanket chased buffalo across the mountains of northwestern New Jersey, we could view the onset of the historical and cultural inaccuracies that have continued to be the hallmark of the Hollywood Indian. Hence Robert Taylor playing a Shoshone of 1865-70 in *Devil's Doorway* (1950) and Richard Dix portraying a Navajo of 1914-20 in *The*

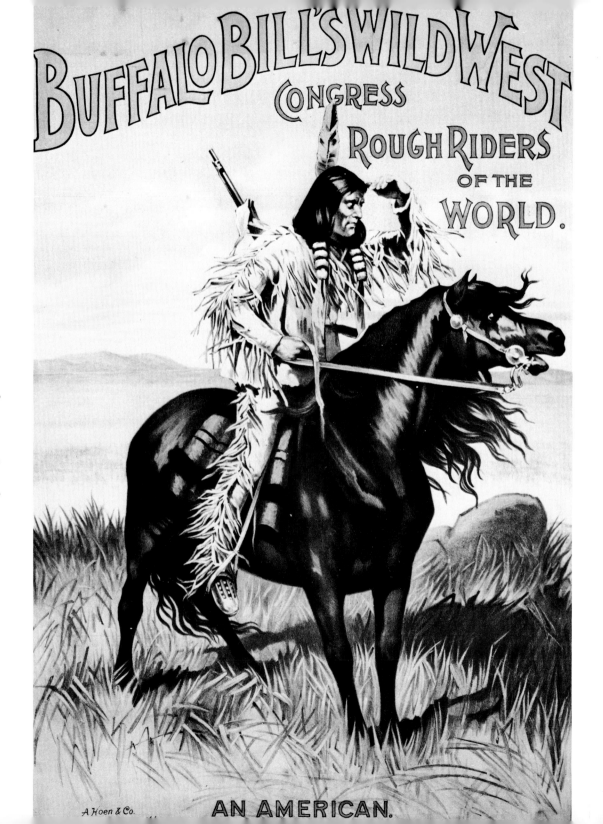

AN AMERICAN.

Original Color Lithograph Poster
Titled "An American," From Buffalo
Bill's Wild West Show, ca. 1887
Courtesy Buffalo Bill Historical Center,
Cody, Wyoming

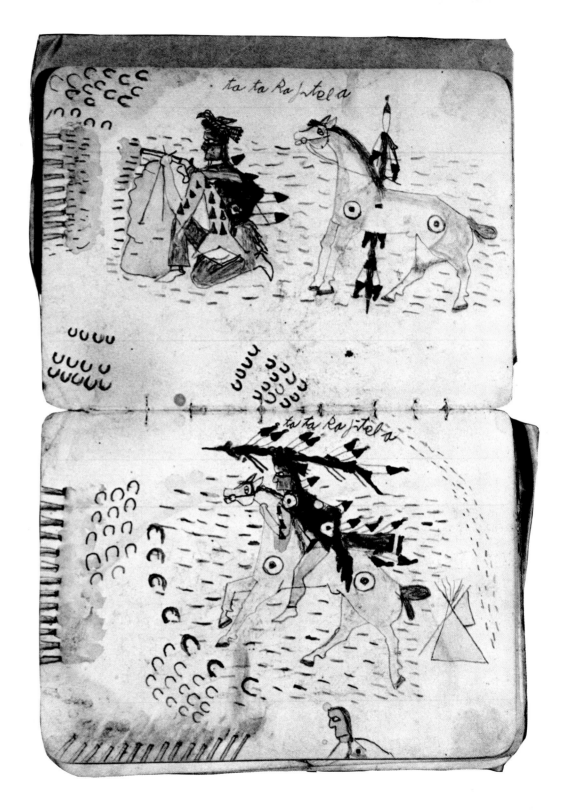

Pages From The Pictographic
Autobiography of Short Bull,
Sioux Indian (1844-1924)
New Jersey State Museum Cat. No. 11119A,
The J.P. Baldeagle Collection

Vanishing American (1926) can wear the same costume. Mohawks of 1776 in D.W. Griffith's *America* (1924) wear Plains Indian beaded leggings and Navajo blankets. In John Ford's *Drums Along the Mohawk* (1939) they wear nineteenth century Plains Indian breastplates. In *Broken Arrow* (1950), while the costuming of the Apaches portrayed is more accurate, a blood-brother style marriage ceremony attributed to the Apaches is sheer fiction. While it is possible to catalog numerous instances of such inaccuracies of costume and custom in the portrayals of Native Americans in films from the 1890s to the present (see Friar and Friar 1972), these problems are not as serious as the movies' dehumanization of Native Americans through lack of historical and cultural context.

> Comanche Chief Tosawi: "Tosawi, good Indian."
> General Philip Sheridan: "The only good Indians I ever saw were dead."
> (Brown 1970:170)

General Sheridan's statement was transformed in American folklore to "The Only Good Indian Is A Dead Indian," and for most motion picture portrayals of Native Americans it could certainly stand as an implicit Hollywood motto. In few films are the Native American protagonists understandable as human beings. In those rare instances, such as in *Devil's Doorway* (1950) and *Massacre* (1934), the Indian hero was also so assimilated he would be virtually unrecognizable as a Native American if he were not wearing his headband. Throughout the overwhelming majority of portrayals of Native Americans on film the audience is presented with no—or worse, an inaccurate—historical context for the on-screen action. This makes the Native Americans—as individuals or groups—incomprehensible in terms of human behavior. This is particularly true for the bloodthirsty savage stereotype.

Apaches of the Southwest are well known to movie viewers in this role. But by 1846 when Arizona and New Mexico became U.S. territory, the Apaches and the Mexican settlers of the area had long been mutual enemies. The Apaches raided the Mexicans for cattle and horses; the Mexicans raided for Indian children to use as slaves. The U.S. government made the Mexican settlers citizens—but not the Apaches. The Apache warrior Geronimo—the epitome of the bloodthirsty savage stereotype in countless films including *Broken Arrow* (1950)—might be more understandable to film audiences if reference were ever made to the fact that his mother, wife and three children were killed in an unprovoked Mexican attack.

> "I found that my aged mother, my young wife, and my three small children were among the slain . . . I silently turned away and stood by the river."
> "I stood until all had passed, hardly knowing what I would do . . . I did not pray, nor did I resolve to do anything in particular, for I had no purpose left. I finally followed the tribe silently, keeping just within hearing distance of the soft noise of the feet of the retreating Apaches."
> (Geronimo 1970:87-88)

FICTION:	FACT:
Indians invariably attacked wagon trains of settlers.	Very few recorded occurrences (Utley and Washburn 1977:9)
U.S. Army always wins unless overwhelmingly outnumbered by Indians.	Small groups of Indians frequently won engagements. (Utley and Washburn 1977:170)
Indian societies ruled by all-powerful chiefs.	The Plains Indian societies usually portrayed were egalitarian: chiefs led but did not "rule."
Indians kill settlers' women and children; army and settlers kill only Indian warriors.	The official policy of the U.S. Army after 1866 was total war against the Indians—surprise attacks on villages with women and children.
Indians always attack forts.	Indians very rarely attacked forts. (Utley 1973:81-82)
Indians only attacked by army groups or settlers when guilty of prior violence.	Army and settlers had difficulty in differentiating among Indian groups and individuals; many documented instances of army and settlers attacks upon Indians who thought they were at peace. (Utley and Washburn 1977, Utley 1973, Brown 1970)

Likewise the Sioux and Cheyenne, frequent film adversaries of the cavalry and settlers, might be more understandable to audiences if it were explained that the U.S. Army under Generals William Tecumseh Sherman and Philip Henry Sheridan pursued a policy of total war against the Plains Indians who had not agreed to confinement on reservations (Utley 1973:51). The army's winter campaign, with its surprise dawn attacks on Indian villages in which women and children were killed, wounded or driven into the snow while their houses and all of their possessions were burned by the troops, was the other side of Plains warfare. That side has rarely been presented on film.

Another favored stereotype film Indian is the noble savage doomed to extinction by the relentless western drive of civilization. *The Vanishing American* (1926), one of the earliest and most extreme versions of the noble savage motif, used the Navajo to make its point. Ironically, the Navajo are one of the largest North American populations in the U.S. Far from vanishing, the Navajo population nearly doubled between 1920 and 1930 (the film was made in 1925), according to U.S. census figures (Truesdell 1930:40). Many Native American groups did not survive the combination of war, displacement and disease with which they had to contend from the sixteenth through the nineteenth centuries. However, many other groups did survive. The prevailing movie presentation of Native Americans as no later than nineteenth century phenomena en route, even then, to extinction conflicts directly with the reality that the descendants of those portrayed are still here and living in the twentieth century. Herein lies perhaps the most serious problem issuing from the movie stereotypes—both bloodthirsty and noble savage varieties.

To the extent that ethnic stereotypes form a part of our world view, they impede understanding of others as fellow human beings. Concomitantly, they diminish our ability to deal realistically with one another. While this is true for all ethnic stereotypes, the portrayal of Native Americans is of particular concern because the only exposure many non-Indians have to Native Americans is through popular films.

First-hand experience, be it confirming or contradictory, does not temper acceptance of the screen image.

In a recent survey of the early days of filmmaking, Kevin Brownlow (in Braudy 1979:12) has argued that "...a fiction film with real settings seems more authentic to an audience than a documentary...." While the documentary film provides extensive references for its portrayals, the popular feature film does not. Aside from publicity releases, the audience ordinarily knows little about how a feature film is made. In the following study, historian John E. O'Connor presents the results of his research into the production of ten representative popular films portraying Native Americans and the often complex processes through which the Hollywood Indian emerged.

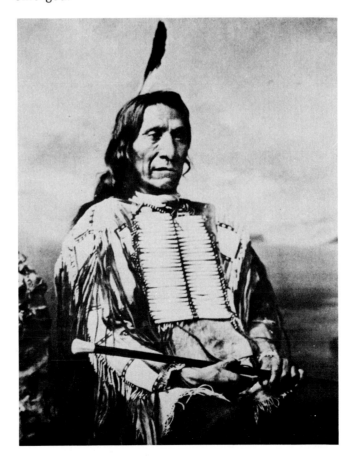

Red Cloud, a Chief of the Dakota (Sioux), as photographed by C.M. Bell in 1880. His campaign against the U.S. Army in the mid 1860s was so successful that the Army in 1868 abandoned the forts which had been constructed along the Bozeman Trail in the Powder River valley and by treaty recognized the right of the Sioux to the area.

Hollywood movies have failed to present an authentic picture of the American Indians. This study neither catalogs the inaccuracies nor surveys the complaints of Native Americans and their supporters over the past three quarters of a century. It goes a step further and examines some of the reasons such stereotyped images have prevailed through the history of the movie industry. Specifically, it will analyze ways in which institutional elements in the process of producing feature films have contributed to the Indians' image and, where possible, will document the influence by citing the manuscript archives of the Hollywood studios.

In 1973 when Marlon Brando refused an Academy Award to protest the treatment of Indians on and off the screen, he expressed a resentment traceable to the earliest days of moviemaking. As early as 1909, moving picture trade journals carried stories criticizing the films' misrepresentation of the Indians. In 1911, a spate of such articles in *Motion Picture World* lamented the existing movie stereotype; and the same year a delegation representing the Chippewa and other tribes traveled to Washington to protest the movies' use of whites dressed in war paint and feather bonnets. The two basic issues—stereotyped Indian roles and the job shortage for Indian actors—have dominated a lively and persistent controversy.

Native Americans themselves have been the major critics of the industry's treatment of their people. Although they are better organized and more effective today than a half-century ago, their complaints remain much the same. A 1939 *New York Herald Tribune* article said that a California group called the Indian Actors' Association was trying to place its members in theatrical jobs by encouraging many to go "back to the blanket," i.e., to study traditions and relearn nearly forgotten skills with an eye to becoming technical experts at the studios.[1] Yet as recently as 1979 the *Hollywood Reporter* could state that the Indian American Talent Guild had "seen little progress in its demand for more roles for Indians in both theatrical and TV films."[2] In the 1960s and 70s, a growing activism and the willingness of more whites to listen influenced protests over the screen

image of Indians. When *A Man Called Horse* opened in 1970, for example, the protests seemed louder than ever. Even with the flurry of press releases explaining the detailed research that had gone into the production and over the objections of the Rosebud Sioux Indians who had helped to make the film, the American Indian Movement mounted picket lines at theaters and handed out leaflets charging that "every dollar going into the box office is a vote for bigotry."[3] Most recently a five-part television series entitled *Images of Indians* dramatized the untruths and the injustices that filmmakers have visited on the Native Americans.

Obviously, a gulf exists between the historical Indians and the movie version. The more recent image of the faultless victim is as absurd as the earlier one, the diabolical savage. An even-handed and objective history of the West would have to admit that both white men and Indians participated in gratuitous violence and that individuals on both sides broke treaties. In complaining about the inaccuracies and the stereotypes, however, not enough attention has been paid to understanding the reasons for the images. In the process of examining this question, I hope that readers will not only consider the image of the Native Americans, but also come to comprehend more fully the complexity of film as entertainment, as art and as a document of American culture.

THE WHITE MAN'S INDIAN

The most obvious explanation for the Native Americans' Hollywood image is that the producers, directors, screenwriters and everyone else associated with the movie industry have inherited a long intellectual and artistic tradition. The perceptions that Europeans and Americans have had of the Native American were emotional and contradictory. Either an enemy or a friend, he was never an ordinary human being accepted on his own terms. As Robert Berkhofer explains in his book *White Man's Indian: Images of the American Indian from Columbus to the Present* (1977), the dominant view of the Indians has always primarily reflected what the white man thought of himself.

As the positive concept of the "Noble Savage" took shape, especially in eighteenth century France, it was conceived as evidence to support the arguments of Enlightenment philosophers such as Rousseau. Such thinkers believed that people would be better off as children of nature, free of the prejudices and conventions imposed by such established European institutions as the monarchy and the church. The negative view of many of the captivity narratives common in the literature of the New England Puritans proved to the faithful that the forces of the Devil were alive and at work in the dark forests of America. Berkhofer argues that from the first contacts of the European explorers, white men tended to generalize about Indians rather than discriminate among individual tribes, to describe Indians primarily in terms of how they differed from whites, and to incorporate strict moral judgments in their descriptions of Indian life. This has proved true in prose, painting, documentary photography—in every art form that chose the Indians as its subject, including film. Consider, for example, the characteristic view of the Indians' relationship to the land. The view—that since the Indian lacked the ambition and good sense that the whites used in developing the American landscape, he impeded progress—has prevailed throughout our history. The movies and television, the popular art forms of today, continue to present images of Native Americans that speak more about the current interests of the dominant culture than they do about the Indians.

To some degree the conclusions proposed in the ten essays to follow support Berkhofer's formulation. As war clouds rose overseas in the late 1930s and early 1940s and the dominant American culture sought to reaffirm its traditional patriotic values, the negative stereotype of the Indian (a traditional enemy) served a broader purpose in films such as *Drums Along the Mohawk* (1939) and *They Died With Their Boots On* (1941). Thirty years later, with America embroiled in a different kind of war and millions of its citizens challenging the government's policies, the movies reflected its divided consciousness. In films of the sixties and seventies such as *Tell Them Willie Boy Is Here* (1969) and *Little Big Man* (1970), Berkhofer perceives that "the Indian became a mere substitute for the oppressed black or hippie white youth alienated from the modern mainstream of American society."[4]

One must take care, however, in drawing generalizations. Even with the gradual shift in public interests and values, certain plot formulas have persisted. The Indian raids, for example, on the stagecoach [*Orphans of the Plains* (1912), *Stagecoach* (1939), *Dakota Incident* (1956)]; on the wagon train [*Covered Wagon* (1923), *Wagon Wheels* (1934), *Wagonmaster* (1950)]; on the heralds of technological progress [*Iron Horse* (1924), *Union Pacific* (1939), *Western Union* (1941)]; on the peaceful frontier homestead [*The Heritage of The Desert* (1924), *The Searchers* (1956), *Ulzana's Raid* (1972)] have changed little. There have been cycles of Indian pictures such as the string of sympathetic films that followed *Broken Arrow* (1950), but at times a romanticized, even glorified, image could coexist with the vicious one. In 1936, for example, when most screen Indians were the essence of cruelest savagery, Twentieth Century-Fox made the fourth screen version of the idyllic Indian drama *Ramona*, starring Loretta Young.

Even in the very early days, when small production companies churned out two-reel westerns weekly for the nickelodeon trade, a patron might leave one movie house where he had just seen a sympathetic—

Original lithograph poster advertising *They Died With Their Boots On*

though not necessarily accurate—Indian drama and walk to another one where the natives on the screen were totally inhuman. Thomas Ince's *Heart of an Indian* (1912), for example, allowed that some Indians might be sensitive people; but D.W. Griffith's *The Battle at Elderbush Gulch* (1914), though it showed the provocation for battle, presented the Indians as absolute savages: they even wanted to steal Mae Marsh's puppy dogs to kill and eat in a ritual sacrifice. Another common Indian image was the comic one in western spoofs such as Charlie Chase's *Uncovered Wagon* (1920), the Marx Brothers' *Go West!* (1940) and Mel Brooks' *Blazing Saddles* (1974). Over the last ten years a series of film documentaries and docudramas, especially those made for television, have taken strides toward presenting the Indians more on their own terms, but by and large the Hollywood product continues to present the white man's Indian.

The serious scholarship of historians, anthropologists and other professionals should have helped to dispel the assumptions that colored the popular concept of the Native Americans. But the conclusions of Helen Hunt Jackson's landmark history, *Century of Dishonor* (1881), and such detailed studies of tribal life as those by Steward (1938) and Eggan (1955) were painfully slow in finding their way into school textbooks and into the broader culture.

FILMMAKING: A COLLABORATIVE ART

This study takes for granted that stereotypes and misrepresentations exist in the movies. Filmmakers who perceive the Indians through the distorted lens of the broader culture will invariably produce movies filled with twisted images. However, in spite of a more or less subtle racial bias, Hollywood is presumably not filled with Indian-haters intent on using their power to put down the natives. One need only observe how quickly a director or a studio might switch from portraying a "bloodthirsty" to a "noble savage" if the market seems to call for it. Far from purposeful distortion, significant elements of the Indian image can be explained best through analyzing various technical—and business—related production decisions that may never have been considered in terms of their affect on the screen image.

Obviously, the artistic process in Hollywood differs substantially from several of the other art forms mentioned. The painter and the poet usually work

This shot of comic Indians firing their bows and arrows from a "bicycle-built-for-four" is from Charlie Chase's 1920 comedy short *The Uncovered Wagon* (Photo courtesy of Killiam Shows, Inc.)

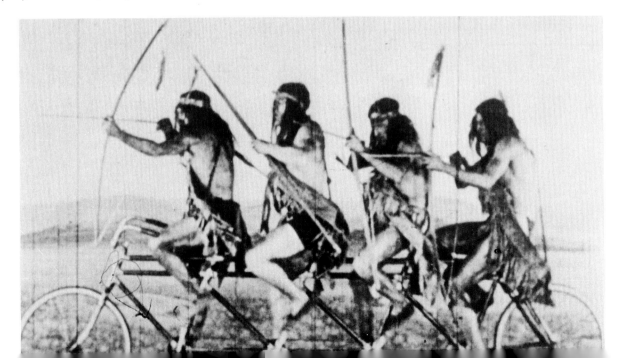

alone, and the product they create is a personal interpretation of the world. Though the novelist may be more conscious of the public's mind, the creative effort he makes is still personal.

Filmmaking, in contrast, is a collaborative art. It requires the creative contributions of dozens of people, who will subtly—sometimes unconsciously—alter the movie's message or the way it is presented. Moreover, although almost any artist would be happy to sell work—to that extent commercial concerns may influence all art—the huge monetary investments necessary to produce a feature film make art and commerce inseparable. If producers, set designers, script writers, cinematographers, directors or actors want to practice their craft, the films that they make must earn a profit. Therefore, the creative process involved in producing a Hollywood movie demands the artistic judgment of a team of professionals and its utmost effort to make the film appeal to the broadest possible audience. The poet, the painter and (to some extent) the novelist may escape these pressures. In some ways, they complicate the analysis of film art more than the other forms, but they are indispensable to understanding a film's point of view.

To simplify analysis I have grouped some of these production factors into three general areas: *dramatic considerations, commercial considerations and political considerations.* These designations are imprecise. Certain elements of filmmaking may fit as well into two or three of the categories while others may not fit easily into any. Such divisions, however, may make the artistic, financial, political and other forces that influence the production process easier to understand.

After examining the three general types of production considerations we will analyze more closely how these factors influenced ten films dealing with Native Americans: *America* (1924), *The Vanishing American* (1926), *Massacre* (1934), *Drums Along the Mohawk* (1939), *They Died With Their Boots On* (1941), *Devil's Doorway* (1949), *Broken Arrow* (1950), *Cheyenne Autumn* (1964), *Tell Them Willie Boy Is Here* (1969) and *Little Big Man* (1970). While all three factors were at work in producing these films, dra-

matic considerations influenced *The Vanishing American* and *Devil's Doorway* more. Commercial concerns did more to shape *Massacre* and *Broken Arrow*. Political factors held sway in *America* and *They Died With Their Boots On*. In analyzing the films, I have given special attention to those factors that can be documented through research, and, wherever possible, have cited the manuscript records of the production studios.

The influence of such production factors is not unique to movies about Native Americans. The three types of considerations figure in the production of every ,Hollywood film. A similar analysis would be fruitful in studying gangster movies or science fiction films. Of significance in analyzing films about Native Americans is the way in which seemingly unrelated production decisions may have superceded interest in historical accuracy or cultural integrity and how they may have dictated the image of the Indian in particular films.

DRAMATIC CONSIDERATIONS

In many ways, film is a literary form. Like a novel, a play, or any other narrative structure, its purpose is to tell a story. The filmmaker (a composite of all the collaborators), like the novelist and the playwright, must resolve questions of format, structure and the relationships of characters so that they are comprehensible to an audience. A good filmmaker, like any other artist, will try to solve these problems so that they illuminate some element of the human condition. Rather than using words on a page or paints on a palette, the filmmaker works with a complex combination of images projected on a screen, and the demands of this medium influence the dramatic structure of the story. This is especially evident in films that have been adapted from another form. *Massacre* began as a book-length, journalistically-styled expose of the state of Indian affairs in the early 1930s. A well-organized and effective book, it dealt with reservation life, unemployment, inadequate medical care and other problems. The film-

makers had to create a different structure using fictional characters with whom the audience might identify. Walter Edmunds' novel *Drums Along the Mohawk* was a best seller in the 1930s. Though some regard it as a classic of historical fiction, the structure did not lend itself to the movies. The story of how the Iroquois "destructives" had terrorized the farmers of the Mohawk Valley year after year was long and episodic. In some ways its drawn-out descriptions of successive attacks must have given the reader a sense of desperation similar to what the colonists must have felt. Decision-makers at the studio decreed that the film script needed tightening and careful pacing to allow a series of lesser climaxes to lead up to a single major climax that would end the film on a positive note.

Whether told in a book or on film, every story has a point of view. Establishing any point of view, especially a complex one, may be more difficult in film than in print. One reason for this is that filmmaking conventions discourage the use of a narrator, preferring the characters to develop the plot and point of view through dialogue. Only two of the films discussed here use narration. They use it sparingly and, as the study of the manuscripts at Twentieth Century-Fox indicates, the narration by Tom Jeffords that begins and ends *Broken Arrow* was a device decided upon at the last minute. The visual medium lends itself well to describing the landscape or the ambience, but communicating the personality of a character becomes difficult. Without a narrator, the audience's perception of what the characters say and do and what other characters say about them is all there is to delineate their personalities. This helps to explain why, even with some narration, Arthur Penn's *Little Big Man* failed to capture the subtle characterization of Old Lodge Skins that Thomas Berger had written in his novel.

Communicating with images can be more difficult than with words. Images are more open to misinterpretation by the viewer taking in the message on a sensual and emotional level, and at a predetermined rate, in contrast to the basically intellectual, self-paced process of reading a book. Unconsciously cam-

era angles, composition, lighting, editing and a host of other factors can influence the viewer's perception. Imagine how difficult it was to develop characterizations before the innovation of sound. The makers of *The Vanishing American* had to try to match Zane Grey's skillfully written characterizations working only with pictures and a few subtitles. Of course, even in the silent era the filmmaker may have provided a musical score for the theater pianist to play along with the film, or he might have tinted the images on the screen to suggest a mood, as D.W. Griffith did for *America*. But the development of synchronized sound and Technicolor further complicated the process of producing and decoding movies. For example, might the funeral scene in *Massacre* have had a different tone if Hal Wallis had allowed it screened with the sounds of weeping and sobbing Indians in the background? In *Drums Along the Mohawk*, would the Indians have seemed so menacing if their painted faces and the farmhouses they set on fire had been filmed in black and white instead of in color?

With few exceptions, Indians have come to the screen most often in films about the American West. As Will Wright points out in his *Sixguns and Society: A Structural Study of the Western* (1975), western films have a mythology and a method all their own. Wright makes it clear that though the western has several standard plot variations, its popularity with filmmakers (and other artists) over the years depends mainly on the human conflicts involved in life on the critical edge between wilderness and civilization that create opportunities for drama. Whenever this drama allows the full development of an Indian character so that the viewer gets to know him, the film almost always induces some empathy. But little time has been spent in developing the screen personalities of Indians. They become flat characters, relatively nondescript evil forces that help establish an atmosphere of tension within which the cattle ranchers, the townspeople, the stagecoach riders, the outlaws, the sheepherders, the cavalry officers, the schoolmarms and the barmaids can relate to one another. As another scholar of the western put it:

The western formula seems to prescribe that the Indian be a part of the setting to a greater extent than he is ever a character in his own right. The reason for this is twofold: to give the Indian a more complex role would increase the moral ambiguity of the story and thereby blur the sharp dramatic conflicts; and, second, if the Indian represented a significant way of life rather than a declining savagery, it would be far more difficult to resolve the story with a reaffirmation of the values of modern society.[5]

Therefore, the demands of dramatic structure and visual communication may have shaped the Indian image in western movies as much as the traditional myths about which Robert Berkhofer has written. In fact, it seems clear that translation into a visual medium, where characters with complex personalities and subtle motivations are harder to portray than simple good guys and bad guys, accentuated the dichotomy between the bloodthirsty and the noble savage that Berkhofer traced back to the beginnings of the white man's experience in America.

2 COMMERCIAL CONSIDERATIONS

For the longest time, Hollywood businessmen reasoned that films had to appeal to the broadest possible audience. In some ways this exaggerated the impact of such dramatic considerations as narrative structure and point of view. For a mass audience, for example, the dramatic situations should be straightforward and unconfused. Typically, the audience could easily decide which characters were good and which evil (white hats or black?), and "moral ambiguities" were kept to a minimum. *Devil's Doorway*, a film that played up complex moral questions related to race and prejudice, is a rare exception to an almost ironclad Hollywood rule.

The same was true for stereotypes of all kinds, particularly, for Native Americans. Moviegoers came to expect Indians to be presented in a characteristic way. The designers of Indian movie costumes have generally given little attention to the actual dress of the tribes in question. Language elements, cultural beliefs and religious rituals of one tribe have been attributed to others or, more often, invented. Frequently, Native American actors have been denied roles as Indians in favor of non-Indian actors whom the producers thought "looked better." The viewer had to be satisfied, but—especially where the finer points of Indian culture and history are concerned—moviegoers have never been particularly discriminating.

Especially in western films, the bloodthirsty, war-crazed Indian has been Hollywood's stock-in-trade. Something different on the screen might distract the audience from the theme of the film. Distract it too often, and it will not be entertained—and selling entertainment is why the movie companies are in business. From time to time the stereotype even had to be reinforced. For *Geronimo* (1939), for example, it was thought that Native American actor Chief Thundercloud would not live up to the public's expectations of a menacing savage. Not only did the make-up artists take on the project of making him look more the part, the publicity department prepared a series of photos for the press that showed the transformation.

It is interesting that the attempt to satisfy the total public usually led to a Hollywood film including some element, however small, of provocation of or explanation for the Indians' brutal behavior. Therefore any viewer of *America* or *Drums Along the Mohawk* who might have found it hard to believe in such bloodthirsty Indians could rationalize that the Tory leaders (played by Lionel Barrymore and John Carradine) had whipped the "ignorant natives" into their frenzy. No one could doubt that the Indian was the enemy in *They Died With Their Boots On*, but the film allowed a grudging respect for Crazy Horse (Anthony Quinn) and stressed the fact that white men had broken their treaty and provoked the Indians' final resort to the warpath.

One reason that westerns have enjoyed such long-term popularity is that they include lots of action, and the Indians have always served such scenes well. Peace-loving Indians, however, make for little excitement. Even in a sympathetic movie, such as *The Vanishing American*, the obligatory battle serves as a climax. The coming of sound further emphasized the

This series of publicity stills from Paramount Pictures show Chief Thundercloud, a full-blooded Cherokee better remembered for his role as the first Tonto in the Lone Ranger television series, in his makeup for *Geronimo* (1939). As the captions provided by the studio explained, movie men didn't think he looked real enough for the title role. Subsequent pictures showed him removing his makeup and relaxing at home, "just another businessman with a good book."
(Photo courtesy of Carlos Clarens)

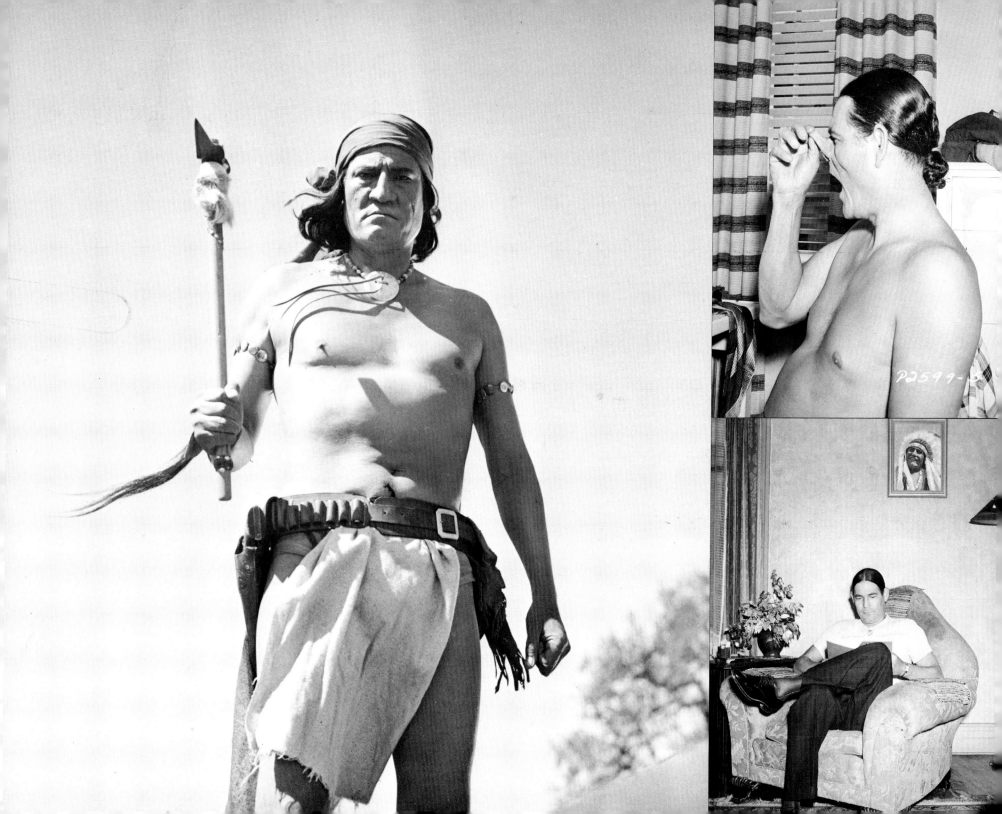

excitement of the Indian attack. The war whoops screeched by the Indians in *Massacre* allowed the studio's sound engineers sensational use of their relatively new medium. The publicity material for *Geronimo* suggested that exhibitors play an Indian sound-effects record in their theater lobbies, with tom-toms and war cries to reinforce the impression that the movie being shown inside was action-packed.

The publicity efforts the studios mounted deserve special attention. Although it may be impossible to determine how much impact such "exploitation campaigns" had on the success or failure of any picture, the studios certainly viewed them as a necessary part of the business. Ironically, in suggesting ways that exhibitors might get public attention for their shows, sometimes the publicity "press books" presented ideas at odds with the theme of the film itself. Such was the case with *Massacre*.

Commercial considerations also help to explain the evolving Indian image. Over time the American movie audience has changed. Since the movies began a financial comeback in the early 1960s, producers have realized that the typical American moviegoer is younger and better educated than his counterpart of the 1930s or 1940s. As a result, audiences want movies to do more than merely entertain. The old stereotypes are less likely to convince today though new cliches seem to have taken their place. And although pressure groups have always tried to control the presentation of particular images in the movies, Indian activists have only achieved any real clout in the last decade or two.

The bottom line of a successful movie, as in any other commercial venture, can be found on the profit-and-loss statement. Low production and distribution costs will make the break-even point easier to reach, and the cost of producing western movies with Indians can be minimal. For example, sets could be put together inexpensively and extras found on the reservation for far less than union scale. The unavailability of most studio financial records makes it impossible to speak with any precision about the actual costs or profits. It is clear, however, that major productions shot on location with large casts of well-known actors become costly. Cost overruns for location shooting on *Cheyenne Autumn* (1964) necessitated the elimination of many scenes, and they may have contributed to the film's artistic and commercial failure.

Finally, a significant percentage of the Hollywood film industry's income since the 1930s has come from foreign sales. A film such as *Tell Them Willie Boy Is Here* could make up for some of its disappointing domestic sales by becoming a hit in Europe, where audiences might appreciate different styles of filmmaking and have different criteria for defining believable and interesting plot-types and characterizations.

③ POLITICAL CONSIDERATIONS

Many would argue that every Hollywood film is a political document. As Russian films have characteristically excoriated the czarist regime and extolled the Revolution, the Hollywood movie industry—imbued as it is with the capitalist ethic—has always supported the political and economic systems on which it relied. Although the process of filmmaking and the role of government may differ considerably, the product is much the same. Apart from this general orientation, however, political factors have influenced the shape of what reaches the screen in more specific ways.

At times political and commercial factors could coincide. When Warner Brothers' early 1930s films of social consciousness, such as *Massacre*, supported the National Recovery Administration and the New Deal that Franklin D. Roosevelt offered the American public, they expressed in part the liberal political point of view that prevailed in Hollywood. But the moviemakers also hoped that their films would ride on the wave of positive popular opinion that accompanied the new president's efforts to reverse the economy. As the American people began to renew their hope in the future, Hollywood movies helped to feed their growing confidence in the new administration.

In another era, when a studio reasoned that as-

sistance from the U.S. War Department could be a crucial element in keeping down production costs, the military's production suggestions could be a great influence. Nothing could be more political· than the way in which Warner Brothers tried to convince the U.S. Army that it should help make *They Died With Their Boots On*. The movie's producers heard suggestions from many quarters about various elements of their project—on the portrayal of the Indians, for example. But the only recommendations that seem to have received close attention were the War Department's ideas on how to portray the U.S. military.

A different type of political influence may have shaped D.W. Griffith's work on *America*, especially the Indians' role in that film. Griffith's papers suggest that he and others on his production staff were sensitive to the demands of various patriotic organizations concerned about the images that got to the screen. The Indians were the only group they could portray as "heavies" without inviting the political wrath of the cultural establishment. In an interview for the recent *Images of Indians* television series, director King Vidor noted that although many minorities and ethnic groups had "lobbies" in Hollywood to protect their movie image, no one spoke for the Indians. Perhaps the ultimate irony is that in western films, where Indians most often appear, producers always have to consider the demands of the American

Humane Society about the treatment of the horses. Unfortunately, the Native Americans aren't treated nearly as well.

International politics could play a part too. As Twentieth Century-Fox prepared *Drums Along the Mohawk* for release in 1939, decision-makers tried to weigh the impact such a film could have on current tensions in Europe. Might Germany read a popular film that played up the long-forgotten hatred and resentments associated with the American Revolution as a sign that the alliance between the United States and Great Britain was perhaps not so secure? This was less likely if Indians and American Tories were the enemy portrayed and no British officers were shown.

Most recently, political influence found its way into movies of the late 1960s and early 1970s in the form of Indian allegories of the American experience in Southeast Asia. The Indian movies made then, such as *Little Big Man* and *Soldier Blue* (1970)—films that indicted Americans for practicing genocide on the Native American—were partly the expressions of the producers' and directors' feelings about Vietnam. Even more important, however, they were commercial products aimed at the moviegoing public of young adults who, by profitable coincidence, also represented the age group most deeply involved in the antiwar movement.

The following short essays illustrate some specific ways that such institutional factors have shaped Hollywood's image of the American Indian. The choice of only ten films made inevitable the exclusion of favorites. Movies such as *The Vanishing American* and *Little Big Man* are analyzed as significant examples of Hollywood craftsmanship. Others, like *Massacre* and *Broken Arrow*, indicate some of the most important trends and cycles in the portrayal of Native Americans. Primarily, however, these films have been singled out because the

available manuscript material makes it possible to study the production process in depth.

Some of the films discussed offer striking contrasts and similarities. *The Vanishing American* and *Broken Arrow* present a "noble savage" stereotype, while *Drums Along the Mohawk* and *They Died With Their Boots On* represent the ultimate expression of the vicious and uncivilized savage. *America* and *Drums Along the Mohawk* deal with the era of the American Revolution, and their production was fraught with worries about how to portray the British as an enemy. Interesting similarities exist in the ways that *The Vanishing American, Massacre* and *Tell Them Willie Boy Is Here* address the pressures of reservation life, even though the contemporary styles of filmmaking (in the silent era, the early sound era and the era of the independent producer, respectively) differ considerably. *They Died With Their Boots On* and *Little Big Man*, made almost thirty years apart, sharply contrast in their views of the United States military and their Indian enemies at times (1941 and 1970) when war was much on the mind of the American public. The producers of other films such as *Devil's Doorway* and *Cheyenne Autumn* bent over backward to sympathize with the Indians' plight, but they did nothing to correct Hollywood's characteristic carelessness in portraying historical events and the complexity of Native American cultures.

To organize the following essays by similarities and contrasts, however, might have confused the central argument thesis of this study. A strictly chronological treatment can concentrate on how dramatic, commercial and political considerations influenced production. It also reinforces the observation that, in spite of the forces that changed the shape of the movie business over the past three quarters of a century and transformed the precise nature of the stereotypes, Hollywood Indians are still far from real.

AMERICA

D.W. Griffith's *America* (1924) shows the Indians of New York's Mohawk Valley and the unprincipled Tories (those still loyal to the king) who egged them on as the most vicious enemies of the colonists' cause in the American Revolution. The film matched the extravagant style and passion for historical detail that Griffith had established in earlier films, such as *The Birth of a Nation* (1915), about the American Civil War and its aftermath. His staff expended great efforts to travel when possible to original locations to use antique furniture as props and actual homespun costumes, to duplicate the color of Paul Revere's horse, and, if the magazine of the Daughters of the American Revolution is to be believed, to cast actual descendants of Revolutionary War soldiers to recreate the battles before the cameras. The first half of the film, with scenes in Williamsburg, Lexington and Concord, and Philadelphia, traces the events of 1775-1776 and intertwines them with a fictional melodrama about a family whose loyalties are split between the British and the Americans. The second half of the film concentrates almost exclusively on the war in northern New York and the conflict between settlers and Indians.

While the British troops had been models of military honor and good conduct, the Indians were barbarous savages. The perfect tools for a diabolical Tory provocateur like Walter Butler (Lionel Barrymore), they would stop at nothing to annihilate the colonists. The film's dramatic structure required a bloodthirsty enemy against which to play off the colonists' heroic patriotism. But Griffith had significant reasons for wanting not to paint the British too negatively. Not the least of his concerns was a desire to market the picture in Great Britain (where it played, in fact, after a few editorial changes). Dozens of patriotic groups and local historical societies pressured Griffith to be sure that the film presented their special interests sympathetically, but no one looked out for the Indian. As a result, in much the same way that black Americans are stereotyped as less-than-human in *The Birth of a Nation*, the worst possible image of the Indian comes across in *America*.

In the mid-1920s if any filmmaker in the United States could produce a movie as he wished, paying no attention to political pressures or special interest groups, that man was D.W. Griffith. It shook him when the National Association for the Advancement of Colored People picketed *The Birth of a Nation* a decade before, forcing it to close in several cities. But Griffith's reputation as the most significant innovator of the motion picture art and his powerful position in his own production company gave him the artistic freedom of which other directors could only dream. Therefore, it is ironic that his production of *America* (1924) offers classic examples of the influence that political pressure and special interest groups can bring to bear.

In 1909 Griffith made a short film entitled *1776*. Apparently he was thinking about a larger project on the Revolution in 1916, soon after completing *The Birth of a Nation*. The Griffith Papers, preserved at the Museum of Modern Art in New York City, include some interesting correspondence between the great director and Robert Goldstein, the New York clothing manufacturer who had provided the costumes for his Civil War epic the year before. Goldstein had his own dreams about becoming a movie-maker, and in August 1916 Griffith opened the way by promising, for the sum of $1 "and other valuable consideration," to delay his own film on the Revolution for at least one year.[6] Subsequent events could only have impressed Griffith with his good fortune and made him peculiarly sensitive to certain issues involved in any film that dealt with America's struggle for independence.

Goldstein went ahead with his plans and produced a film entitled *The Spirit of '76*. Unfortunately, by the time he finished it the United States was involved in the war in Europe, with Great Britain as its ally. Soon Goldstein found himself in federal prison for violating the wartime sedition act—he had made a movie that portrayed our allies, the British, as the bad guys. It is not clear when Griffith first learned of Goldstein's troubles, but in May 1920 Harvard law professor and civil rights activist Zachariah Chaffee wrote to Griffith for a character reference that might help to get the poor fellow out of jail. "Is he the sort of

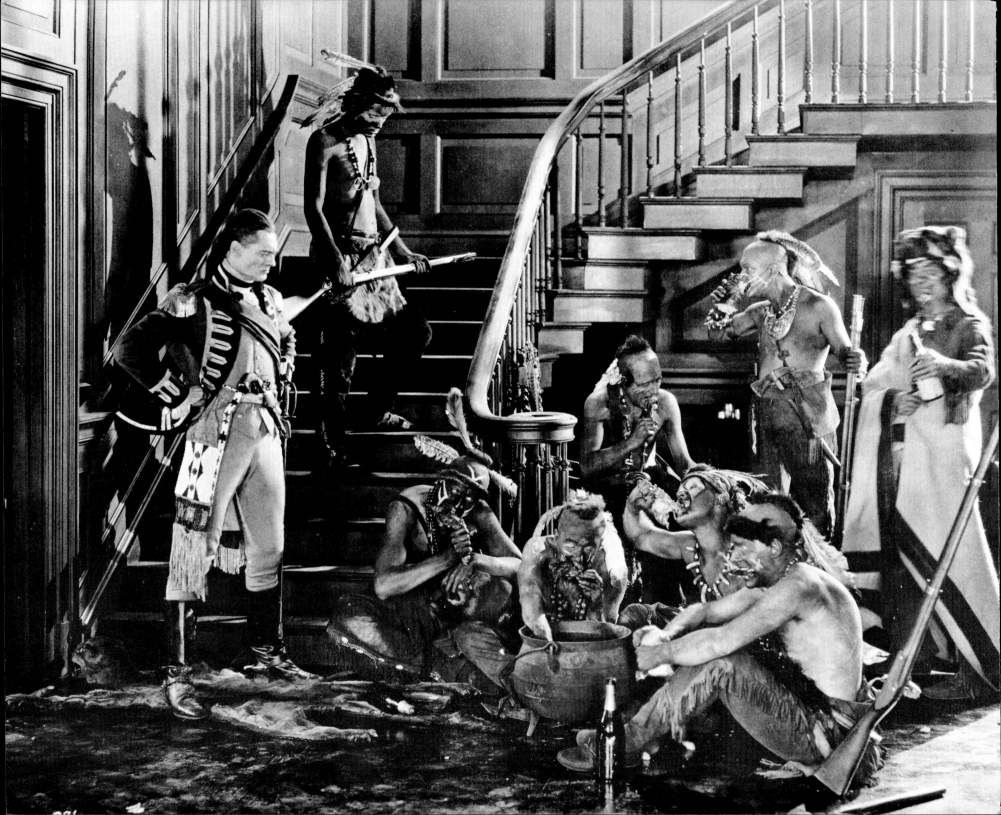

Tory leader Walter Butler (Lionel Barrymore) in movie America's version of Johnson Hall during American Revolution. Griffith's passion for historical accuracy did not extend to Indian costuming or the very modern bottle in the foreground. Barrymore wears a nineteenth century beaded Plains Indian pipe bag.
(Courtesy of the Museum of Modern Art/Film Stills Archives)

Joseph Brant, the educated chief of the Mohawks, is seen chatting with Miss Montague in America. The Chief was most effective as the dynamic leader of the Indians against the colonists at the battle of Oriskany.
(Courtesy of Killiam Shows, Inc.)

Portrait of Mohawk leader Joseph Brant painted by Romney ca. 1775-76. The portrait may have served as the model for Brant's costume in America.
(Courtesy of National Anthropological Archives)

person," Chaffee asked, "who would deliberately produce anti-British scenes in order to embarrass this country in the prosecution of the war?" Griffith's cold and businesslike reply, that Goldstein's motives would have been "almost entirely commercial," may have shown some lack of sympathy, but the plight of his protege impressed him and, conceivably, influenced him when a few years later he began to make his own movie about the Revolution.[7]

According to the souvenir program produced to sell for 25¢ in theaters showing America, the direct impetus to begin work on the project that Griffith had held on the back burner for so long came from the Daughters of the American Revolution. Throughout the stages of research and production, the leaders of the DAR, the Lexington (Massachusetts) Historical Society, Boston's Old South Association and similar patriotic groups showered their attentions on the famous filmmaker. They offered to lend him priceless family manuscripts that would "illuminate" the history of the Revolution. They volunteered their eight-

eenth century historic homes as sets and their valuable antiques as props for the movie. But most important, they offered advice. A letter to Mr. Griffith from Henry Johnston of the Thomas Jefferson Memorial Foundation was typical. Johnston was worried that George Washington might get all the glory.[8]

Robert W. Chambers wrote the scenario for the film, and an expert on antiques designed the "historical arrangement" (sets and costumes). The filming was completed in the summer and fall of 1923. Griffith had done all in his power to present the British in a positive way, a major feat considering the hatreds inevitably engendered by a protracted and bloody war. In large part Griffith achieved his goal by concentrating the bulk of the filmed battles and skirmishes in northern New York, where Indians and Tories fought the king's battles for him. Several reviewers noted the obvious imbalance in the portrayal of events. All sorts of patriotic heroics in the middle-Atlantic and southern states were passed over to stress the activities of Tory leader Walter Butler and

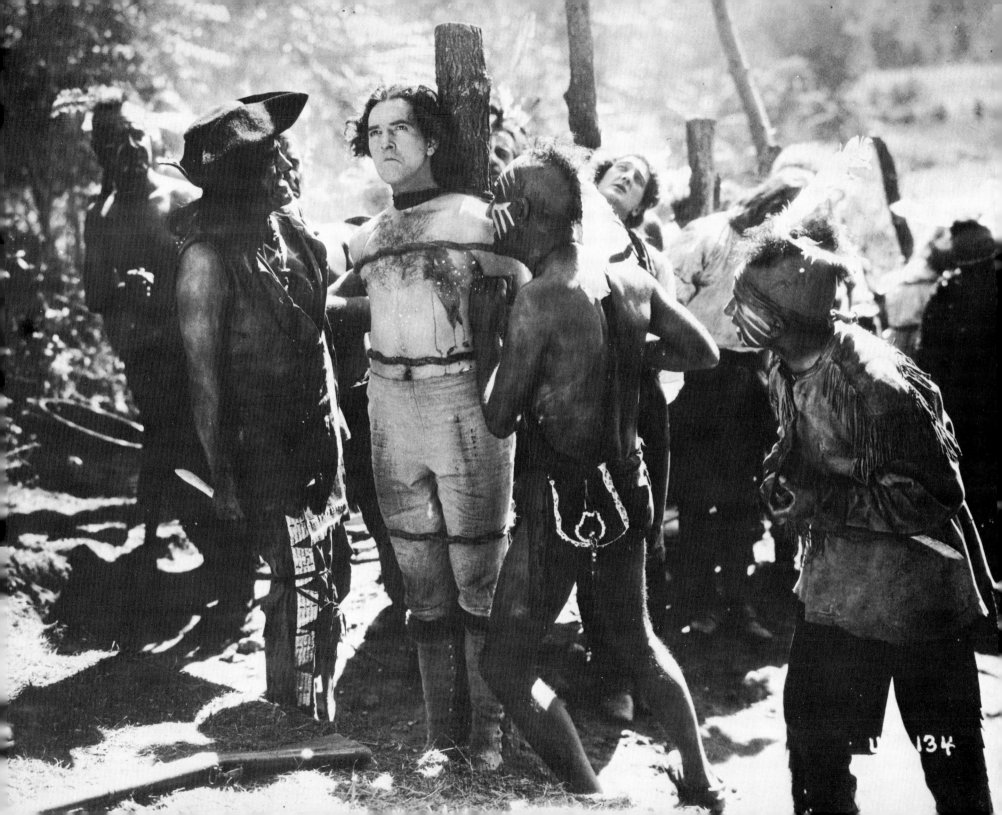

Tory leaders and "Mohawks" torture colonists in America. Plains style beaded trouser bands are worn by the Tory on the left in this 1776 scene. (Courtesy of the Museum of Modern Art/Film Stills Archives)

the Indians under his command. But any portrayal of the British marching through the peaceful New Jersey countryside, attacking Philadelphia, or ravishing the Carolinas would have painted a harsh picture of the Redcoats. Griffith and Chambers, his writer, were most sensitive about this.

Mrs. Charles White Nash, New York State Regent of the DAR and member of its national committee on public relations, noted this in her personal response to a special preview of the film. She had serious reservations about Griffith's taste in showing camp followers traveling with the army. She even threatened to withdraw her endorsement and cancel plans to sponsor school trips to the film unless such "repulsive" scenes were deleted. But on the portrayal of the British she was more than pleased:

> It appeared to me as quite remarkable in that, although it depicted our great struggle with our mother country, England, there was nothing that aroused a feeling of antagonism against the English who were our opponents. It left one with a feeling rather of pride in our own patriots after the manner of good sportsmanship.[9]

But no one spoke up for the Indians as "good sportsmen," and audiences were left with a reaf-

firmation of their attitudes toward the incorrigibly violent Native Americans.

There are a number of reasonable explanations for the filmmaker's Anglophilia. First of all, Griffith had been honored a few years before by a Buckingham Palace showing of his film *Intolerance* and an invitation from the British Government to make another movie, *Hearts of the World*. In the words of film scholar William K. Everson, his sincere "goodwill toward Britain knew no bounds."[10] Then there were commercial concerns. Griffith planned to distribute the film in England with as few changes as possible. Since he had some trouble when the British film censors banned the first viewing, he did some cutting and reworded some of the titles to make them less jarring to British sensibilities, and the film passed British muster. The movie was shown in England under the title *Love and Sacrifice*. Finally, there were current political pressures and what must have been a vivid memory of Robert Goldstein moldering away behind bars.

One reviewer, to Griffith's and Chambers' dismay, interpreted the movie as anti-British. Chambers responded personally to the critique in terms that

Pair of beaded Plains Indian trouser bands collected in 1890s (N.J.S.M. cat. no. 15317). Note similarity to those worn by America's Tory leader in "Mohawk" costume.

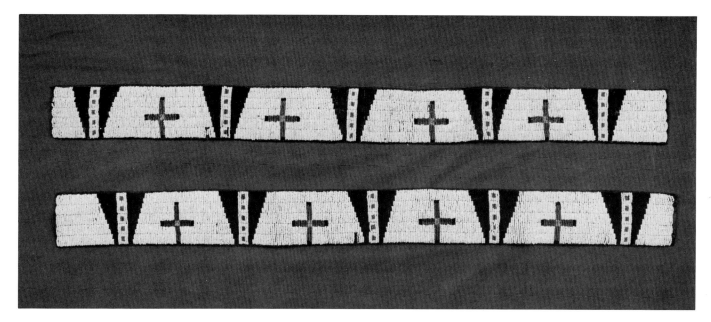

directly related to contemporary political issues. He assured the reviewer that he and Mr. Griffith were both "pro-British" and went so far as to say that he personally favored a formal alliance between the United States and Great Britain. It was 1924. Just a few years earlier the United States had refused to join the League of Nations or to make any firm commitments to European nations after the World War. American isolationists may have prevailed in the U.S. Senate's rejection of Woodrow Wilson's post-war treaty proposals, but the war had reinforced the traditionally-strong, popular affection for Great Britain (as Robert Goldstein had learned the hard way), and Chambers wanted to leave no doubt about where he stood.

The screenwriter went on to defend Griffith's and his decision to concentrate on the war in the Mohawk Valley. The British had planned this campaign to split the northern and the southern colonies, he reminded. If they had succeeded there was no telling what might have happened. As Chambers proclaimed, "I regard the capital Battle of Oriskany (where the Americans held off the Indians' attack) as one of the great decisive battles of the world." Then he pointed out that he fully understood the other reasons why it made sense to concentrate on the war in New York:

> Almost all of the cruelties committed in the Northland were done by the American loyalists or Tories, not by British. It was the German king of England, and Lord George Germaine who employed the Indians as allies. The British officers strove to control and restrain them. But the American Tory officers—men like Sir John Johnson and Walter Butler—made little effort to curb their ferocity.[11]

Robert Chambers gave the British people themselves, therefore, the Parliament, even the British army, a clean bill of health. He suggested that King George III's actions could best be explained by his German ancestry (he was of the House of Hanover) and the influence of his corrupt minister. Once riled, the Tory leaders neither could nor would pacify the ferocious Indians, who bore the ultimate responsibility for the carnage in America's struggle for nationhood.

THE VANISHING AMERICAN

Famous Players Lasky-Corporation, then the producers of Paramount Pictures, billed *The Vanishing American* (1926) as the American Epic. The film, based on the novel of the same name by Zane Grey, was set on a Navajo Indian reservation in the period 1915-1920. More clearly than any other feature film of the period, *The Vanishing American* presented the ideal of the "noble savage," but it did so in an ideological framework not calculated to please those anxious about preserving Native American civilization. Steeped as it was in the intellectual vogue of "the survival of the fittest," the film, like the book, was based on the premise that the Indian way of life was doomed to extinction.

The story was about an Indian brave named Nophaie (Richard Dix) and Marion Warner (Lois Wilson), the white school teacher with whom he had fallen in love. Both struggled against the forces of corruption on the reservation, centered in the character of Booker (Noah Beery), the assistant to the government's Indian agent. Significant changes had to be made in converting the novel to a motion picture, partly because of the difficulty of telling a complex story on the silent screen and partly to satisfy the demands of movie audiences who had come to expect lots of vigorous action. For example, since war movies had proved to be popular products in the 1920s, the producers of this film played up the main character's service on the battlefield in France. The best example of tailoring the story for the movie audience, however, came at the conclusion. The screenwriters had Nophaie die violently at the end of the film, cut down by a blast of machine gun fire in the midst of a colorful Indian battle. According to the novel, Nophaie's passing had been nothing so special—he had died from a case of the flu.

The Vanishing American is tragic drama—a fatalistic examination of how (as of 1925) modern American civilization was slowly extinguishing the noble and innocent Indian race. Although the film generates genuine sympathy for the Indians, nowhere does it suggest that their fate is alterable. Nowhere does it

Nophaie (Richard Dix) is shown seated adoringly at the feet of Marion Warner (Lois Wilson). Their love was as doomed as the Indian civilization in *The Vanishing American*.

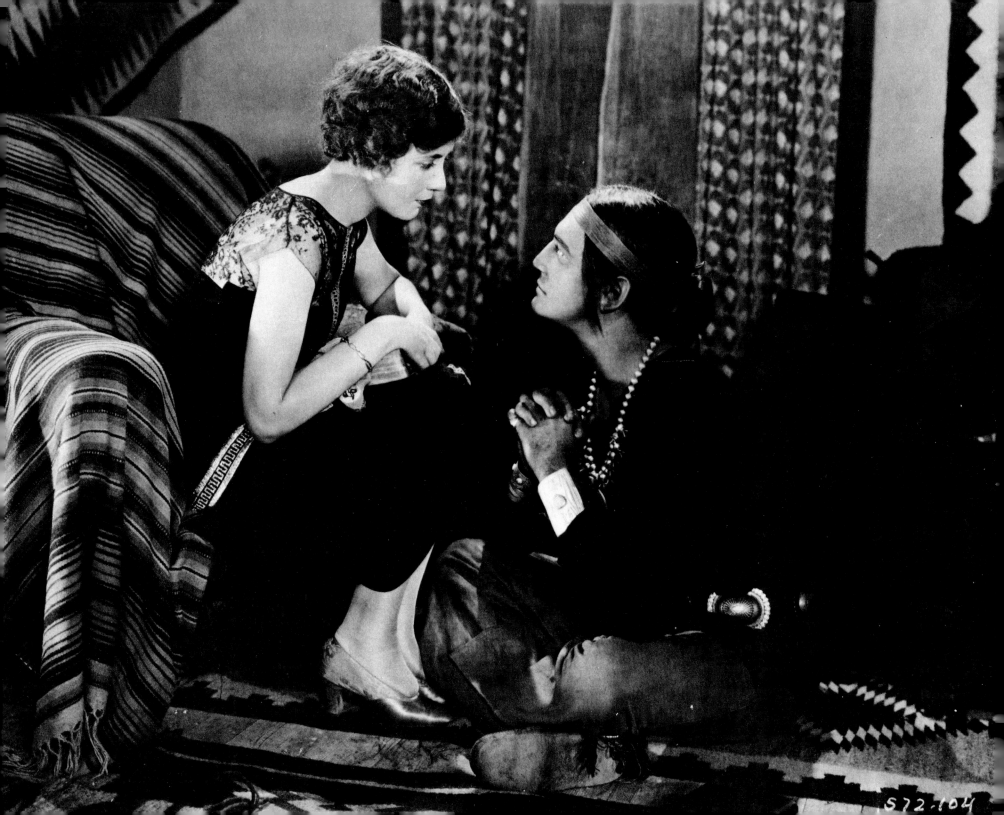

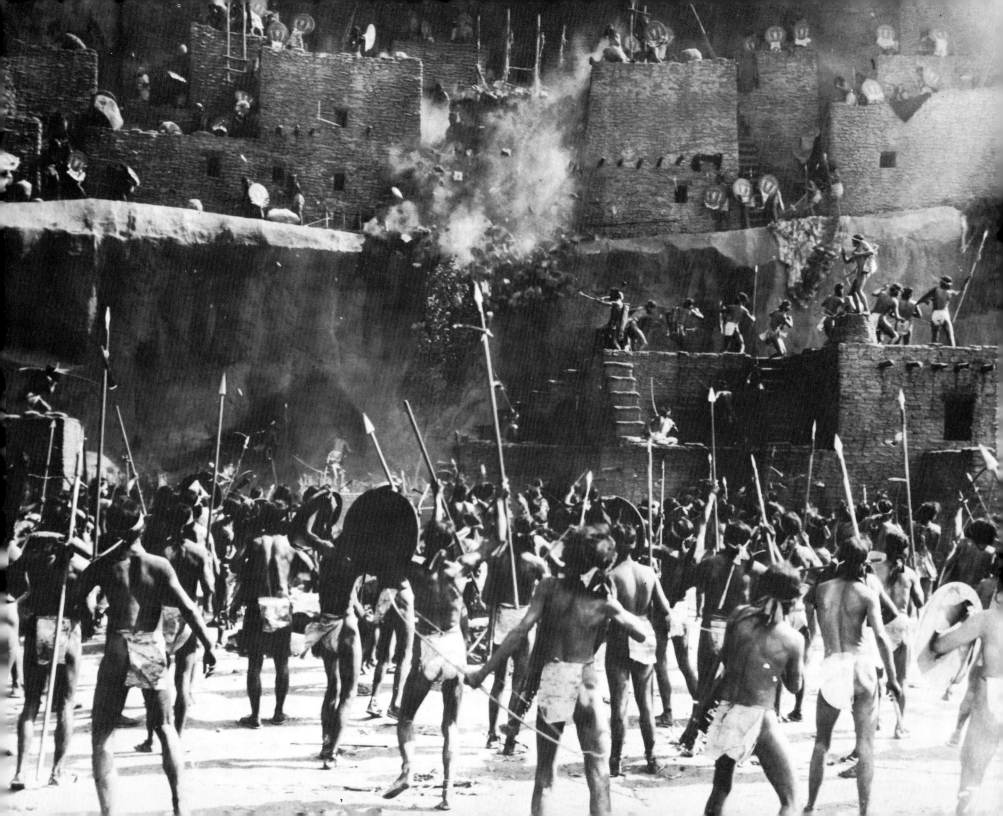

argue resistance to their demise. A title early in the film quotes the essence of social-Darwinistic philosophy that infuses the film. It is highlighted again in the souvenir program produced for sale in theaters showing the film: "We have unmistakable [sic] proof that throughout all past time there has been a ceaseless devouring of the weak by the strong . . . a survival of the fittest."[12]

This was the central theme of Zane Grey's novel on which the film was based, but the producers at Famous Players-Lasky Corporation (then the production arm of Paramount Pictures) chose to accentuate the message further by adding an extended prologue tracing the history of human life in the Southwest back to "caveman and cavewoman." After introducing in turn the "basket makers," the "slab house people," and "cliff dwellers" and describing the physical and cultural traits of each in a few words, the film concentrates on the invasion from the North of "a younger fiercer people . . . the first of what we call Indians." As they attack and conquer the last of the pueblo villages, a cliff community religious leader places a curse on the invaders, "May a stronger race come and scatter you to the four winds." Though purely hypothetical history, as a dramatic framework for the story to follow this suggests a larger significance for more recent events. The prologue continues, dramatizing the coming of the Spaniards in the sixteenth century ("so began the conquest of the Indian") and jumping to Kit Carson's solemn promises in the name of the "Great Father in Washington." By 1900 the Indians had been forced to an arid reservation with one strip of fertile land for planting. The centuries-old curse seemed to be coming true, but the story poignantly points up the tragedy experienced in the death throes of Native American civilization.

The body of the film, like Zane Grey's novel, concentrates on the period just before, during and shortly after World War I. Although Jesse Lasky himself claimed to have given Grey the idea for the story while they toured the Navajo reservations in Utah and Arizona and although from the outset Grey wrote intending that Lasky's company film his work,

he made some interesting changes of plot and characterization before *The Vanishing American* was ready for the cameras. The story that Grey published for the first time in serial form in the *Ladies Home Journal* in 1922 and 1923 powerfully rendered the ideal "noble savage." The main character was an Indian whom a group of well-meaning white women kidnapped from the reservation as a boy and sent off to a special Indian school where he became Christianized. Eventually, along with his college degree he earned a reputation as a great athlete. Given the name Nophaie on his return to the reservation, the young man became a leader of his tribe. But as much as the white man's education had helped him to understand how the corrupt men who ran the reservation victimized the Indians, the white man's religion conflicted with his self-image as an Indian and his ability to respond to his people's needs.

Into this setting rides Marion Warner, a beautiful blonde whom Nophaie had met and fallen in love with while studying in the East. Unsure of her future plans but longing to see Nophaie and to understand his feelings of loyalty to his people, she decides to devote time to working as a teacher among the Indians. They enjoy a tender reunion, but Marion's presence further complicates Nophaie's situation by reminding him of his split personality. His wish to remain an Indian and wander free in what was left of his people's once-rich land was difficult to carry out. He had come to the white man's ways, and he could no longer accept without question the ancient beliefs of his tribe. Grey's sympathetic and romanticized image of the Indians, presented a biased and unreal view:

> Indians are not what they appear to most white people. They are children of nature. They have noble hearts and beautiful minds. They have criminals among them, but in much less proportion than have the white race.
> The song of Hiawatha is true—true for all Indians. They live in a mystic world of enchantment peopled by spirits, voices, music, whisperings of God, eternal and everlasting immortality. They are as simple as little children.[13]

The novel's white characters who dominate the

reservation personify vice and corruption. They cheat and steal from the Indians, denigrate tribal customs and traditions, and deny the Indians human dignity. Worst of all, as the overall social-Darwinistic premise of the theme demanded, these villains come out on top in every confrontation. One person in the studio's story department responded as follows to his first reading of the story:

> The story is one of heart-rending distress, in which injustice, greed, and the baser passions are invariably triumphant and *remain un-punished*. There is conflict, but the weak and just always give way to the strong and unjust. There is suspense—but the feared always happens ... Every character (without exception) that earns the sympathy or respect of the reader is either dead or left in a pitiable plight at the end of the story; and the miscreants who are the authors of this misery and death, are smugly hale, hearty, and prosperous. If it is the intention of the story to make the white race appear, in general, as a poor thing in comparison to the "Noble Red Man," the author has certainly succeeded. It is difficult to see how, in view of the harrowing character of the story, it could be made available for pictures without radical revision.[14]

With such revision in mind the screenwriters went to work. They considered the character of Nophaie and his relationship with Marion in Grey's novel too complex to present clearly and effectively on the silent screen. Therefore, the film's scenario cut all references to the young Indian's education in the East. Instead, it presented Nophaie (Richard Dix) as an intelligent but illiterate native whom Miss Warner (Lois Wilson) teaches to read the Bible. Though in the film a loving, if uncomfortable, relationship develops, they do not span the cultural gap as they do in the novel, until Nophaie goes off to fight as a doughboy in the Great War.

Characterizing the villains also presented prob-

Costuming in The Vanishing American *was more accurate than in most of Hollywood's Indian films. Nophaie wears a Navajo silver squash blossom necklace very similar to this one (N.J.S.M. cat. no. 30.53) made in the early 1900s.*

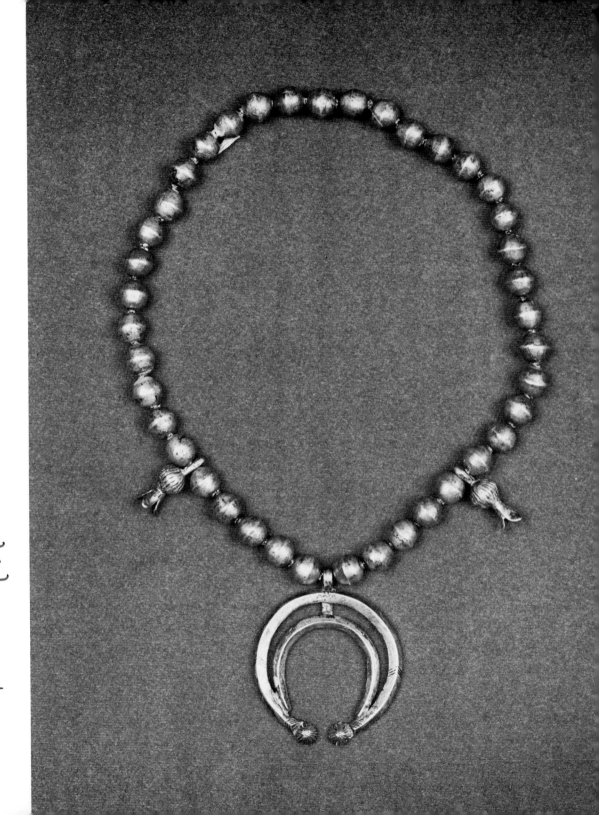

24

lems. As Grey had it, the worst of them was a power-hungry missionary who (in a most unchristian way) dominated the reservation's official personnel through blackmail and intimidation. In contrast, no missionary appears in the film. The most corrupt character is Booker (Noah Beery), the assistant to the official Indian agent, Mr. Halliday (Charles Crockett). The agent is an ineffective bureaucrat, too busy shuffling the papers on his desk to notice his assistant is fleecing the Indians. Since the nature of the corrupt activities Booker and his henchmen were involved in had to be more tangible for the screen, special stress was placed on their efforts to cheat the Indians out of their horses.

Events in the novel were rearranged considerably to tighten the story for the screen and to focus on the major characters. Therefore, Nophaie, rather than the domineering minister, saves Marion from Booker's sexual advances. While Nophaie is in the desert hiding from the revengeful Booker and his cohorts, Marion (rather than a friendly trader) brings him news of the outbreak of war with Germany, and a dramatic exchange takes place. Marion explains that the war is being fought "for freedom, a new order, a new justice," and the Indian reasons "Maybe if we fight and die for our country things will be better for our people." When they return to the agency where Nophaie convinces other Indians to enlist with him, an army officer's search for horses to purchase for the war effort leads to the revelation of Booker's crime. As Nophaie and his brothers march off to war, it appears that all will be straightened out at home. But, alas, this is not to be. Nophaie fights valiantly in France, risking his life to save a buddy's. But on his return, matters are worse. With typical bureaucratic efficiency, the inept Halliday has been called to service in Washington. Despite his record as a crook, Booker has become the Indian agent.

At the end of the film—as in the closing chapters of the book—Nophaie is torn between loyalty to his

Navajo blankets such as this chief's blanket (N.J.S.M. cat. no. 66.100) made in 1880-1890, became popular tourist items by the early 1900s.

people, in desperation preparing an attack on Booker and his men, and his moral sense, which tells him that violence and murder will solve nothing. Zane Grey's conclusion appeared ludicrous to the screenwriters: after convincing the Indians to remain peaceful, Nophaie dies as a victim of an influenza epidemic.[15] In terms of the historical situation, it may have been realistic—thousands of Indians died in the epidemics of the period. Besides, the ending avoided the objections of racial purists to the idea that the Indian and the white girl might marry and live happily ever after. But the conclusion as Grey had written it, a build up of the excitement of an impending Indian war only to have the protagonist succumb to the flu, would never satisfy a movie audience.

The original film scenario, preserved in the Paramount Collection at the Academy of Motion Picture Arts and Sciences in Beverly Hills, discloses how the scriptwriters dreamed up a sensational alternative. Suggesting that Booker had also bamboozled the Indians out of some oil discovered on their land, the writers had the Indians "dynamite the oil wells and so start a slowly moving flood of blazing oil down on the agency . . . by morning, they calculate, the whole place will be a blazing inferno." In this version of the story, Nophaie rides to the town warning the inhabitants, all of whom believe him and flee—all, that is, except Booker who is engulfed in the flames. Nophaie is wounded, but he survives. He dramatically tells Marion that they can never marry, for he must stay with his people who then "carry his litter off into the West."[16]

Presumably, the costs and production problems associated with such a sensational climax were foremost in the producers' minds when they decided to have the battle fought more traditionally with guns against bows and arrows. The film ends with Nophaie dying in the arms of Marion. He had been cut down by Booker's new toy, a war-surplus machine gun. Nophaie's last words suggest that he finally understands the essence of the scripture that Marion had tried to explain to him earlier. But the Indians as a people at the end of the film are still closer to extinction than they were at the start. Noble as the

Native American may be, the irrevocable laws of social-Darwinism are bound to take their toll. As the last title of the film proclaims, "For races come and go, but the great stage remains." Looking back on the film, the final irony may be the producers' decision to use the Navajo—whose population was actually increasing—to represent the vanishing American.

MASSACRE

The Indians in *Massacre* (1934) are the opposite of the images of the free and untamed savage typical of the western movie. The leading character of Joe Thunderhorse (Richard Barthelmess) has made it in modern-day, white America. Having accepted the white man's way, he has become well-educated, financially successful and self-assured. In contrast, his Indian brothers on the reservation are society's victims, desperately poor and suffering the results of deep-rooted corruption in the administration of Indian affairs. More important, they are weak and powerless, apparently unable to act on their own behalf to remedy their situation. Executives at Warner Brothers, certain that they knew what the public expected to see, carefully held to the stereotype of the silent and stoic Indian. In specific scenes such as the one in which Thunderhorse's father dies, they intentionally played down any emotional display. In the end it took Thunderhorse, with the help of a young Indian girl (Ann Dvorak), to champion the Indians' cause and win the help of the government in Washington against the forces of corruption on the reservation.

Massacre (1934), one of a series of films of social consciousness Warner Brothers produced in the early and mid-1930s, concentrated on current problems. To one extent or another, each of these movies—including *I Am A Fugitive From A Chain Gang* (1932), *Heroes for Sale* (1933), *Wild Boys of the Road* (1934), *Black Fury* (1935), and *Black Legion* (1936)—represented a call for reform, but first they were commercial products designed to turn a profit for the company.

At the beginning studio executives were reluctant

to address current events directly. But in 1932 Darryl Zanuck, refusing to listen to the warnings of his colleagues, initiated the production of the first of this genre, *I Am A Fugitive*, a film based on the true story of a World War I veteran whose difficult read-justment to life at home led to his victimization by the southern penal system. Zanuck even insisted on re-taining the controversial ending designed by screenwriters Brown Holmes and Sheriden Gibney, despite the contention at the studio that a film about such problems would depress audiences enough without making them sit through an unhappy ending. As it was, the film concluded with the hero turned criminal by the corrupt system of law enforcement, still a hunted man with no hope for the normal life he obviously deserved. Once the movie proved suc-cessful (*Variety*, the theatrical trade journal, noted record-breaking attendance at theaters all over the country), Warner executives rushed to congratulate Zanuck for his perception of the public taste and looked for other stories that would allow them to duplicate a proven formula.[17]

What they found was Robert Gessner's 1931 book *Massacre*, an open indictment of America's treatment of the Indians. *Massacre* included descriptions of youngsters being whipped at Indian schools, scandal-ously inadequate medical care, and government agents' mismanagement of Indian lands and financial accounts. Such charges were not new. In recent years several congressional investigations had turned up similar abuses that made nationwide headlines. Films such as *The Vanishing American* had focused on the activities of corrupt and venal officials on the reser-vations. In *Massacre*, Warner executives found a set of ideas around which they could create a successful movie. At the same time, they popularized the prob-lems of the Indians and raised the public conscious-ness.

Cameras are being set up on the set of *Massacre*
for a shot of Chief Thunderhorse (Richard Barthelmess)
and his Black valet sitting in the chief's
custom-built roadster—a symbol of the success
and self assurance he has gained in white society.

Richard Barthelmess in full regalia for the Wild West Show as portrayed in *Massacre*. As soon as the show was over, the Chief rushed back to his dressing room where his valet helped him change into a stylish white double-breasted suit and a ten-gallon hat.

The central character was an Indian who had succeeded in white America, a graduate of Haskell Institute, the Federal Indian school at Carlisle, Pennsylvania, who became a star of the Wild West Show at the 1933 Chicago World's Fair. Although he was the son of a Sioux chief, Joe Thunderhorse (Richard Barthelmess) wore monogrammed, white double-breasted suits and a huge Stetson hat. He drove a custom-built roadster. A sophisticated bachelor, he had to fight off designing socialites (one of whom says, "I'd be that chief's squaw any day"). He lacked awareness of his people's real problems.

A trip back to the reservation to visit his dying father brings him face to face with the kinds of corruption and injustice described in Gessner's book. On the most basic level the film is about how Joe comes to understand the plight of his people and how, with the help of an Indian girl (Ann Dvorak) and Franklin D. Roosevelt's new Commissioner for Indian Affairs, he begins to set matters straight. At the same time, the film catalogs many injustices and indignities associated with life on the reservation and encourages the audience to identify with the cause of reform.

Much of the acting in the film is wooden and unimaginative. A few of the scenes strain credibility: for example, the one in which Thunderhorse stands in his speeding roadster to lasso the local undertaker, played by Sidney Toler (soon to become Charlie Chan). Perhaps the involvement of the same screenwriter, Sheriden Gibney, explains why the plot, with kangaroo courts, prison escapes, and victimization of the innocent, seems to parallel that of *I Am A Fugitive From A Chain Gang*. In some ways, however, the cliche-ridden story line strengthened the social message of the film. Viewers were not so gripped by Thunderhorse's personal story (as they may have been with *I Am A Fugitive*) that they missed the broader context. Where the corruption evident in *The Vanishing American* seemed to be the work of evil individuals, *Massacre* suggested that the problems went deeper. They resulted from generations of powerful forces in society (such as lumber interests, oil interests and grazing interests) that had been

The movie industry's censors were concerned about this scene of Thunderhorse romancing his white girlfriend in *Massacre*, but Warner Brothers allowed it to remain.

(Photo inset:)
Elaborately beaded items, such as this Sioux blanket strip (N.J.S.M. cat. no. 18775) were made by Plains Indian groups during the late 1800s and early 1900s. Note similarity of blanket strip in foreground of scene in Indian museum from Massacre.

As Thunderhorse alights from a freight car in which he has traveled to Washington with the police on his heels, the audience of *Massacre* is shown the blue eagle symbol of the N.R.A. which was displayed in shop windows all over America as a sign of support for the New Deal of Franklin D. Roosevelt.

taking advantage of the Indians. As Thunderhorse states the case in his testimony before a U.S. Senate committee: "You used to shoot the Indian down, now you cheat him and starve him and kill him off by dirt and disease. It's a massacre any way you look at it."

Jack Warner, the head of the studio, was an active supporter of F.D.R. and the current head of the Motion Picture Producers and Distributors Association (MPPDA). This industry group had just signed an agreement with the New Deal's NRA that allowed studios to continue their profitable monopolistic distribution practices. It might even make it more difficult for independent theater owners to stay in business.[18] As they did with other Warner Brothers films, such as *Gold Diggers of 1933* and *Wild Boys of the Road,* the producers found a spot in *Massacre* for the NRA's blue eagle symbol to indicate approval of the administration's efforts. This was also the moviemakers' attempt to play on the president's obvious

popularity for their advantage. Corporate documents indicate that studio executives were also aware that at that moment Congress was at work on reform legislation that would become the Indian Reorganization Act of 1934. Warner Brothers hoped that the press attention focused on these political events would help advertise the picture.[19] Still, the film's conclusion seemed to compromise the urgency of the situation. Unlike the haunting ending of *I Am A Fugitive,* which emphasized that the problems of a corrupt and dehumanizing system of criminal justice still had to be corrected, *Massacre's* ending suggested that the Indians' problems were matters of the past and that the administration in Washington would soon have everything straightened out.

The Warner Brothers studio files, now preserved at the University of Southern California, offer a unique opportunity to study the factors that helped to shape the Indian stereotype. Hal Wallis (Zanuck's successor

as production chief for the studio) took special pains to instruct Director Alan Crossland on the way he wanted this picture made. Their extensive correspondence of dozens of interoffice memos includes Wallis's injunctions on how Indians should look on the screen. Everyone knew, or at least so Wallis thought, that Indians "are stoical and do not give vent to their feelings so much."[20] They would not put arms around each other in embrace, they would not show emotion openly. In a scene in which Thunderhorse enters the hut where his father is dying, Crossland had shown the Indians grieving for their dying chief. Wallis seemed flabbergasted that the director could have the Indians "crying and blabbering instead of standing around in stoic silence as they would do."[21] Eventually the studio film editors were put to work trying to cover up such "inaccuracies," as Wallis called them. The scene was cut to play down the emotional display, and music was inserted over the live soundtrack that Crossland had recorded. A similar problem "spoiled" the footage Crosslnd shot of the old man's funeral. As Wallis wrote:

> We are trying to point out a condition of illiteracy among these Indians and here they are all standing around singing and reading words out of the hymn book and they must be pretty intelligent to do that. What we should have done was had [sic] the minister singing and then the cuts of the Indians should have been with them with their heads down and mumbling something or other without the books.[22]

Aside from equating literacy with intelligence, an assumption many scholars would question, Wallis thought audiences would not expect Indians to be "intelligent." They expected them to stand around and "mumble."

By the early 1930s Warner's publicity people, among the most respected in Hollywood, dreamed up some stunts to sell a movie that might have influenced the public as much as the movie itself. In the case of *Massacre*, at least, the crassness of the publicity effort undercut some of the sensitivity in portraying the Indians' problems on screen.

The pressbook made available to the managers of all the theaters that showed the film proclaimed "100 MAMMOTH MERCHANDISING IDEAS GEARED TO BLAST THE ICICLES OFF EVERY POCKET-BOOK IN AMERICA." It was filled with "inside stories" about the production that exhibitors were encouraged to use in getting the newspaper to print free publicity. One of them described the two weeks Richard Barthelmess had spent in Palm Springs before shooting the film to acquire the obligatory suntan. Another story suggested that the social and economic problems the film presented may not have been so real after all. It was reported that the so-called "poor" Indian extras were avid to get the financial news each morning: "most of them were playing the market. And you can't do that with sawdust."[23]

One wonders whether the producers and the publicity people communicated with each other at all. The film purported to treat the Indian sympathetically and showed Barthelmess as the hero urging his people not to "sell their birthright." In the film the white Indian agents are being paid off to have a black "entrepreneur" from Connecticut declared an honorary Sioux Chief, hoping that it will increase the sales of his patent medicine. But the film publicity actually belittled Indian customs and traditions. For one thing, it claimed that none of the Indians remembered how to do their tribal dances and that an "expert" had to be called in to give them lessons. Whether true or not, such a story could not have helped the Indians' image. The final embarrassment was a report of how Ann Dvorak had been "fascinated by the rhythm" of the Indian dance and had converted it into a popular ballroom step. As the pressbook explained, "She and her husband tried it out at a Hollywood night club and soon everyone was dancing the SIOUX STOMP."[24]

DRUMS ALONG THE MOHAWK

Drums Along the Mohawk (1939) is a pastoral tale of a young married couple, Gil and Lana Martin (Henry Fonda and Claudette Colbert), trying to make a life for themselves in the beautiful and fertile Mohawk Valley of New York in the 1770s. The events

As *Drums Along the Mohawk* newlyweds Gil and Lana Martin (Henry Fonda and Claudette Colbert) arrive for the first time at his cabin in the wilderness, the harmless old Indian, Blue Back (Chief Big Tree), brings them half a deer as a present. Then he gives Gil a stick which he recommends the new husband use to whip his wife into shape.

of the American Revolution and, more specifically, the activities of the Iroquois Indians whom the Tories (such as the one played by John Carradine) encouraged to attack and destroy the farms of peace-loving colonists, introduced dramatic tension into the story. Walter Edmunds' novel, on which the film had been based, referred to the Indians as "destructives" and traced in episodic fashion the experiences of the settlers, who never knew when the ferocious beasts of the wilderness would sweep down on them. According to Edmunds, who seemed devoted to telling the story as factually as possible, the colonists had from time to time replied in kind to the Tories' attacks. At one point Gil Martin joins a raiding party that sets torch to a Tory settlement and brutally rapes its defenseless women. This was not the sort of thing that clean-cut American young men like Henry Fonda could do in the movies, but no such taboos existed about portraying the Indian. The novel included scenes of peaceful domestic life in Indian villages, suggesting that these savages might indeed have a human dimension, but no such images appeared in the film. There was one "good Indian" in the movie—a Christianized but dull-witted character named Blue Back (played by Chief John Big Tree, a Native American and a Hollywood regular for years who also appeared in *Massacre* and *Devil's Doorway*)—but he was a caricature used more for laughs than for dramatic balance. This movie, that forty years later many still regard as the best Hollywood film to deal with the American Revolution, clearly reinforced the movie stereotype of Native Americans as godless demons, while the whites (Caldwell excepted) were humane and caring people.

In *Drums Along the Mohawk* the Indians' image was doomed from the start.[25] Darryl F. Zanuck, production chief at Twentieth Century-Fox, had purchased the movie rights to the book in 1936, even before it went into circulation, but from the outset the problems in adapting this story for the screen were clear. The difficulties surfaced in the first treatment the studio's story department prepared. Zanuck thought there were too many characters to follow, too

many overly complex characterizations, too much overt emphasis on the patriotic theme, and a narrative that was too long and confused. Describing himself as "not terrifically enthused" about the project, he considered several offers from other companies to purchase the property. Only the book's continuing popularity (by 1939 it had gone into 39 printings) encouraged him to stick with the story.

Like his competitor, David O. Selznick at MGM, Zanuck prided himself on historical and period dramas such as *The House of Rothschild* (1934), *Les Miserables* (1935), *Clive of India* (1935), *Lloyds of London* (1937), and *In Old Chicago* (1938). These films succeeded because he realized that audiences did not plunk down dollars at the box office to learn a history lesson. They came to be entertained, and Zanuck was especially concerned with how the story developed in the screenplay would appeal to a mass audience. At every stage in the work Zanuck maintained close contact with his writers, dictating detailed conference notes that specified places to tighten the story and techniques to heighten the drama. To a script draft of December 22, 1938, he responded:

> In the first place, let us get it understood that we do not want to make a picture portraying the revolution in the Mohawk Valley. We want to tell a story about a pioneer boy who took a city girl to the Mohawk Valley to live and we must tell the story of what happened to them—their ups and downs, their trials and tribulations—the same as it was told about the Chinese couple in *The Good Earth* (1937). In *The Good Earth* the producers wisely discarded chapter after chapter of the book and concentrated on the personal story and on the one spectacular trick with the locusts. We must follow this example. We have in the script practically all of the necessary ingredients to accomplish this but now they are dissipated and lost in rambling jumble of historical and revolutionary data.[27]

Evidence such as this, drawn from the story files of Twentieth Century-Fox in Hollywood, differentiates clearly between Zanuck's approach and the one D.W. Griffith assumed some fifteen years earlier in making his film about the Revolution. Both filmmakers wound up emphasizing the evils of the Indians, but

Zanuck seemed more concerned with dramatic continuity than with political pressures. Griffith was trying to teach a history lesson, but Zanuck knew better:

> We must not let ourselves be bound by the contents of the book—but simply retain the *spirit* of the book. We must concentrate our drama, tighten what plot we have and make it more forceful—so that we build to a big sustaining sock climax where we let everything go with a bang. So long as we capture the general line, the characters, the period—we can and should forget the book.[28]

As Zanuck made abundantly clear, "We are in business to *Give a Show* . . . Our first job is to Make Entertainment."[29] Though such observations will not surprise students of the Hollywood film, locating manuscript evidence to prove the producer's motives is worth the effort.

One way to simplify and shorten the narrative was to omit scenes that might have taken place in the Indian village. This would only have complicated matters for the audience, for whom the story presumably flowed more smoothly without implications that the savage Indians were people, too. To tighten the story and focus it on the "sock climax" Zanuck had

called for, the writers paced the film around three climactic episodes that involved attacks by the blood-thirsty savages. In several cases history had to be compromised. For example, the Indians' final attack on the women and children cowering in the fort and their rescue by a line of continental troops was total fiction. But the entertainment values were superb.

Skilled technicians went to work designing a major production, one of the first films the studio had made with the expensive new Technicolor process. Painted "redmen" and burning farmhouses looked more frightening filmed in vivid color.

A few of the film's most memorable and humorous scenes suggested that the Indians were childlike and stupid. Consider the scene in which Mrs. McKlennar (Edna May Oliver) discovers that a party of Indians has set fire to her house. She is still in bed, and she startles the Indians when they begin to lift her covers. Incensed that they should invade her privacy and terrified that flames may destroy the bed that she and her husband Barney had shared for so many years, she browbeats the invaders into moving her cherished piece of furniture before the fire can reach it. The Indians' power is indomitable, but it fails when placed against the will of a woman whose mind is made up.

After they have worked for more than a year in improving their home, fencing their land, and raising a crop, the Indians sweep down on them and burn everything. The vivid Technicolor photography of *Drums Along the Mohawk* made scenes such as this one all the more effective.
(Courtesy of the Museum of Modern Art/Film Stills Archives)

Mohawk cradleboard, probably nineteenth century. (Courtesy of American Museum of Natural History cat. no. 50.1/1542). Mohawk women and children are not seen in Drums Along the Mohawk.

Light fowling pieces such as this mid-eighteenth century American-made example were used by the Mohawk Indians of New York.
(Courtesy of Professor Donald Baird, Princeton University)

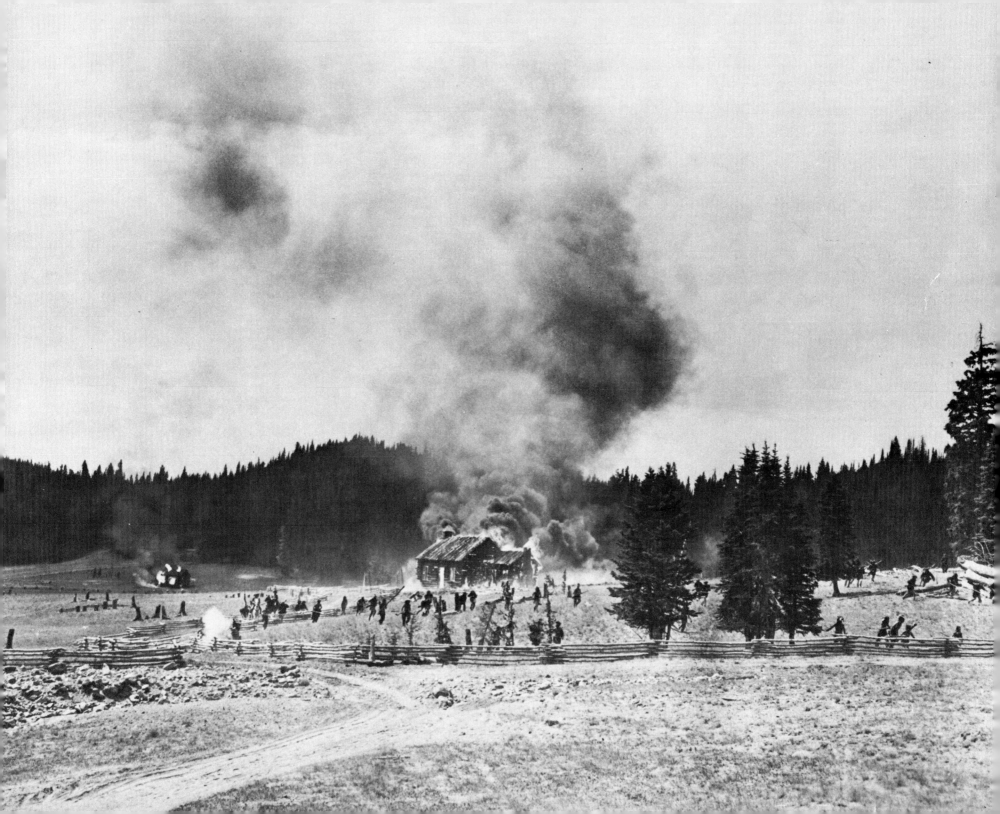

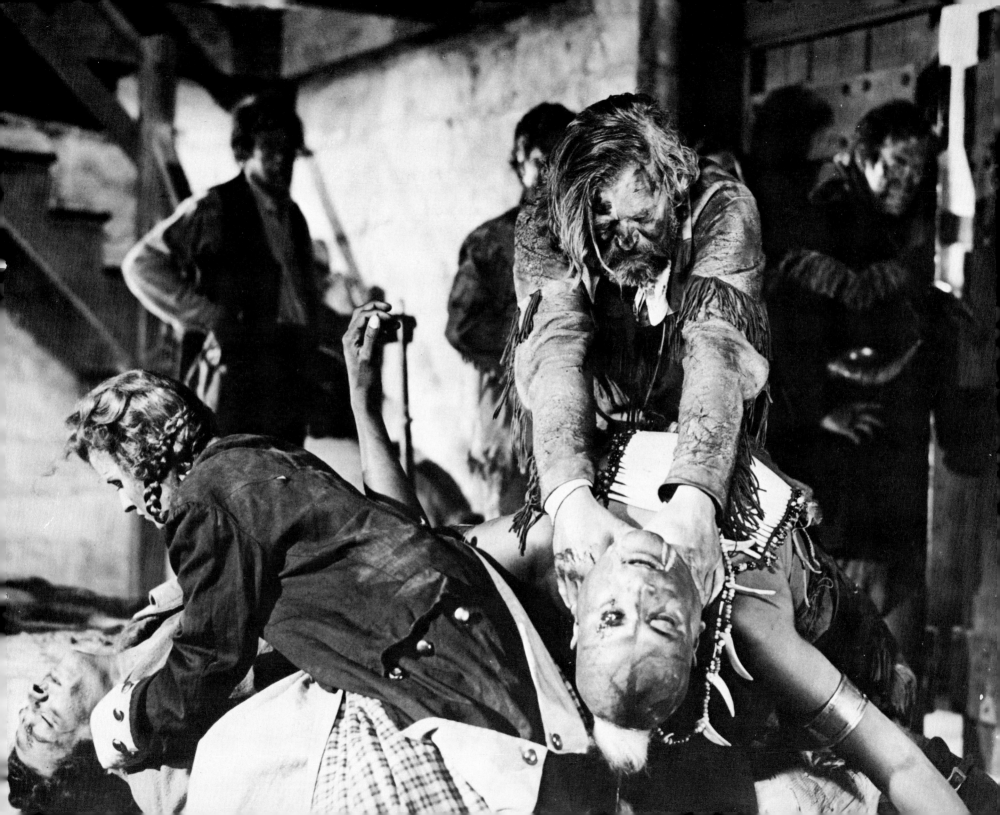

Finally reinforcements arrive and rout the Indians in *Drums Along the Mohawk*. The last intruder is strangled into the hereafter as several of the other colonists calmly look on.

In the same way that the Indians provide the dramatic background against which to characterize the united colonists, they also help to dramatize the development of individual character roles. When Lana Martin arrives at her new husband's cabin in the woods, for example, she quakes with fear at the sight of Blue Back, an old and harmless Christianized Indian. Clearly she must go a long way before she can overcome her squeamishness. The story shows her coming more and more to grips with the realities of life in the outlying settlement. But the fulfillment of her growth as a character comes in the final climactic attack on the fort when she summons the strength to fire her musket in the face of an oncoming Indian. As in hundreds of other Hollywood movies, the Indians in *Drums Along the Mohawk* serve an essential dramatic purpose—they help the audience to understand the strength and honor of the whites.

The preliminary press material on *Drums Along the Mohawk* included a still photograph of Carradine as the Tory leader conferring with a group of British officers. Careful to avoid an international incident, the studio deleted this and any other shots identifying the British. Their greatest concern was the overseas sale of the film and the fear that some people might read a film critical of the British (even the British of 150 years earlier) as an indication of America's feelings in 1939. By implying to the Axis powers that the American Revolution had left a lingering resentment against England, the film might weaken England's stance in her war of nerves with Germany. Ordinarily the studio would have considered the film innocuous but, as one interoffice memo explained, "now the international situation is so delicately balanced, that the powers that be in England weigh feathers and might find the picture injudicious."[30]

THEY DIED WITH THEIR BOOTS ON

In *They Died With Their Boots On* (1941) the Indians play their traditional movie role: the crazed and savage enemies of civilization who block progress as the nation settles the West in the decades after the Civil War. The film focuses on the career of General George Custer, whom the movie represents as a national hero despite historical evidence to the contrary. The studio hoped that a film showing principled soldiers fighting valiantly to preserve and defend the American way of life might appeal to audiences that, throughout 1941, became increasingly conscious of how the war in Europe threatened the United States. With this in mind, the studio even sought—unsuccessfully—the War Department's assistance in making the movie. The film admits that a few individuals, such as the Sioux Chief Crazy Horse, might be honorable men. But, even though several studio advisors recommended that the Indians in general be treated more as "real people having desires, hopes, loves and hates," the stereotype prevailed. If Custer was to be a hero, the image of the Indian had to suffer.

They Died With Their Boots On turned out to be one of the most notorious anti-Indian films ever produced, but for most of 1940 it was a title in search of a story. Sometime before Warners studio had purchased the movie rights to a book of that name that contained a series of vignettes on the lives and deaths of the great villains of the American West. After some thought the producers decided the subject would make a poor film; however, since the title had special appeal, they put writers to work finding a story to fit it.

The theme they decided on, the legend of George Armstrong Custer and his famous defeat at the Little Big Horn, had been known to every school child for more than a half century. The general and his men had been glorified, in part to justify the final extermination of those Indians not yet herded into reservations and as the result of the efforts of Custer's widow to defend her husband's reputation. Anyone who cared to scratch the surface of the popular myth would learn that Custer had enjoyed a tarnished military career. Although his search for personal glory included dreams of becoming president, scholars were aware of his poor academic performance and his long record of poor military judgment and disobedience. In the popular media, however, the heroic image had prevailed: at least a dozen films had

This production still shows the scaffolding that Warner Brothers cameramen used to put themselves in the middle of the swarming Indian attack on Custer's troops in *They Died With Their Boots On.*

Indian leaders gathering in a pow wow with Crazy Horse (Anthony Quinn) in *They Died With Their Boots On* are dwarfed by all the camera, lighting and sound equipment. The man in the white suit at the left of the doorway is director Raoul Walsh.

been made about "Custer's Last Stand" before Warner Brothers got around to producing *They Died With Their Boots On*.

The film was structured in two parts. The first dealt with Custer's experiences at West Point and his service in the Civil War. Having already decided to portray Custer (Errol Flynn) as the great hero, the producers faced the problem of explaining how a young man who was graduated with the worst academic record in the history of the military academy and was court martialed for insubordination could develop into a great military leader. Their solution was to present Custer as an all-American Huckleberry Finn-like nonconformist cut-up who may have begun with naive dreams of glory but came to cherish high ideals.

In the Civil War sequences Custer earns medals for disobeying orders and promotion to general through a ridiculous mistake. The latter half of the film portrays Custer's successful efforts to whip into shape a ragtag frontier regiment and lead it in a campaign to pacify the West by killing Indians and forcing those remaining into reservations. The film villified a group of corrupt entrepreneurs who garnered government contracts to set up trading centers in military outposts and then falsified reports of gold discoveries in the Black Hills to encourage a rush of settlers into the area. According to the film, Custer had first valiantly fought the Indians into submission and then given his word to Crazy Horse, the young Sioux chief, to protect their sacred Black Hills sanctuary. The unscrupulous traders made the fatal confrontation at the Little Big Horn inevitable.

Corporate records preserved at the University of Southern California indicate that Hal Wallis and others at the studio anxiously sought the assistance of the War Department in Washington for technical information and other assistance "in the way of horses, men, requiring the men to put on uniforms of the period, the possibility of getting Indians from reservations if there are any reservations near cavalry camps, etc."[31] The government had offered such cooperation to Hollywood producers in the past, in part at least at taxpayers' expense, if the film project in question might improve the public image of the armed services. In May 1941 the studio sent a representative to Washington to discuss the situation with the Adjutant General's Office. He carried a copy of the script and a letter that screenwriter Aeneas MacKensie had written to Wallis explaining his purpose in writing the film. MacKensie's letter was probably written with knowledge that it might influence the government's decision, and it has to be read with that in mind. Nonetheless, his observations on the screenplay offer interesting insight into how the film reflected the concerns of the period in which it was made.

"In preparing this scenario," MacKensie explained, "all possible consideration was given to the construction of a story which would have the best effect upon public morale in these present days of national crisis."[32] The crisis involved the war in Europe. Given America's support to Great Britain and her allies, it seemed only a matter of time before the United States would become an open belligerent. Pearl Harbor may have been months away, but the army was gearing up and MacKensie thought that his film might serve a special role:

> I need not mention that this picture will be released at a moment when thousands of youths are being trained for commissions, and when hundreds of new and traditionless units are being formed. If we can inspire these to some appreciation for a great officer and a great regiment in their own service, we shall have accomplished our mission.[33]

While admitting he had taken "certain liberties" with history, MacKensie defended the script on the grounds that instead of inventing the story elements he had simply "manipulated" the historical facts.

The studio's efforts were doomed to failure. The Adjutant General found the script unsatisfactory for a whole list of reasons, particularly its inaccurate portrayal of West Point, the characterization of corrupt army officers and U.S. Senators, and the suggestions that most of the soldiers on the frontier were drunk most of the time. Although the War Department refused to reconsider assisting the production, Warners executives decided to accept as many of the

Shooting Star, the Indian sitting in the tepee in front of a hotel on busy Cahuenga Blvd. in Hollywood, is picketing in protest against the studio's hiring of dozens of Indians from a reservation in North Dakota to play roles in *They Died With Their Boots On*. The actor is supposedly angry because he needs the work, but the whole scene has the looks of a studio publicity stunt.

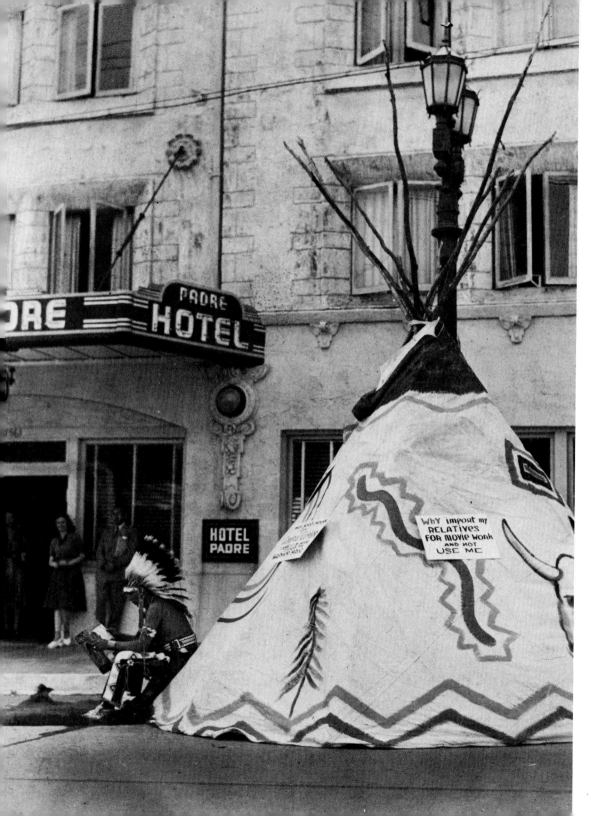

On the sign in the photograph: "WhY import my RELATIVES FOR MOVIE WORK AND NOT USE ME"

army's suggestions as they could. As Wallis put it, "We want to go as far as we possibly can in making changes even though the War Department is not cooperating as we don't want to build up any antagonism against possible future cooperation."[34]

It should be no surprise that in "manipulating" Custer into a national hero, the image of the Indian had to suffer. About the only fact that the film did not "manipulate" about the last battle was Custer's defeat. Historians generally agree that Custer foolishly blundered into battle and wasted the lives of his men because of poor military judgment and a consuming thirst for glory. The Indians had him outmaneuvered and outfought. As the film shows it, however, Custer knew he was taking on a suicide mission and courageously sacrificed himself and his regiment in a desperate effort to keep the enraged Indians from causing still more widespread death and destruction. A sequence shows Custer and his men, including a transplanted Englishman (remember it is 1941), die with pride. Even the unprincipled Taipe has to admit the righteousness of Custer's decision. After the battle we learn from Custer's wife (Olivia DeHaviland) that his sacrifice was not in vain, for it allowed other units nearby to regroup and marshall for the ultimate victory.

The film acknowledges that the Indians' treaty guarantees had been violated, thus somewhat justifying their attack; and it treats the character of Crazy Horse with some respect, if not much understanding. Warner Brothers' corporate manuscripts suggest that certain people at the studio wanted to treat the Native Americans more sympathetically. Screenwriter Howard Koch, for example, advised that the first half of the script be scrapped to allow concentration on the issues related to the Indians. Studio executive Melvin Levy thought that "the Indians need not be presented as lay figures whose sole function in life is to 'masacre' [sic] and be wiped out, but as real people having desires, hopes, loves and hates."[35] Another Warners spokesman, Lee Ryan, tried to remind those involved that the battle at the Little Big Horn was "not a 'massacre' at all, but a very fair fight in which the army was outmanoeuvered and

outgeneraled.'' Ryan also though it a mistake to cast the main Indian character as a young man:

> That, as I see it, is an affront to the Red Man because their Chiefs, their sages and their medicine men were not youngsters but mature men of wisdom for whom the tribes had great reverence and respect. The name of Crazy Horse means nothing to the average American, who is not a student of Indian history, but the name of Sitting Bull (truly a tremendous character) is known to everyone. For that reason I can't see how you can kiss him off with a mere mention of his name. To me, it is as though you were making a story about Thomas Jefferson and incidentally mentioned the name of Washington somewhere along the line. Perhaps I'm out of line a country mile (and I'm giving due consideration to production costs) but I can visualize a great scene with Sitting Bull delivering one of his magnificent phillipics to the assembled chiefs after which Chief Joseph outlines the strategy of battle.[36]

Like many well-meaning suggestions, this image would have been just as false as the others. Chief Joseph's and Sitting Bull's presence at the same battle has no historical basis, and we must wonder at Sitting Bull's attitude toward a chief of the Nez Perce planning Sioux battle strategy. At least Lee Ryan thought that the dignity of the Indians should be preserved. As the film was made there was no indication that the Indians were intelligent enough to plan detailed strategy before they rode out to fight like crazed savages. Sheer numerical superiority, not better military judgment, won the day for the Sioux.

DEVIL'S DOORWAY

Devil's Doorway (1949) is an unusual exception to Hollywood's unwritten rules of filmmaking that dramatic situations be kept unconfused and that moral ambiguity be avoided. The film was part of a cycle of Post World War II movies [including *Gentleman's Agreement* (1947), *Crossfire* (1947), *Pinky* (1949)] that addressed problems of race and bias. The leading character is Broken Lance (Robert Taylor), a Shoshone Indian who returns home as a Civil War Congressional Medal of Honor recipient only to learn that Wyoming has been opened to "homesteaders" and that Sweet Meadows, the tract of land that his family has called home for generations, is about to be taken from him. As an Indian, Lance is considered a non-citizen (Indians were not legally accepted as Americans citizens until 1924) and therefore not qualified to hold legal title to the land. The film pits Lance and Orrie Carmody (Paula Raymond), a young woman attorney who has taken up his case, against a corrupt land agent (Louis Calhern) and the settlers he has encouraged to come in and take over the land. Caught between are the townspeople, who know Lance and his family as fine, respectable people. However, they are driven by the practical demands of the situation and an underlying prejudice against Indians in general to side with the settlers against their friend. As Lance dies defending his home, the victim of his neighbors' complacency, the message conveyed to the audience is an earnest plea for racial tolerance.

Although this 1949 MGM film is especially important in a study of the Hollywood Indian, the decision to make it a film about Indians was an afterthought. By the early 1950s a major reversal of the Indians' movie image was underway, but such a change did not take shape overnight. The first major film to mark this shift, *Devil's Doorway*, had been in the works at the studio for at least three years. The effective black and white cinematography, the direction of Anthony Mann, and the acting of Robert Taylor with a strong supporting cast, all contributed to the success of the film. What is most interesting is how the plot was tailored to fit the post World War II American audience as Hollywood had come to understand it and how this helped to dictate the eventual Indian theme.

The screenplay grew out of a short story by Guy Trosper entitled *The Drifter*. When the studio first saw it in the fall of 1946, it bore little resemblance to what finally appeared on the screen. Trosper's protagonist was Barney Walton, a wealthy rancher respected as the first citizen of Medicine Bow. He used his influence to protect his interests and to handpick the sheriff and other local officials. What only he and a few of his ranch-hands knew was that Barney Walton was really Ira Coffee, a notorious outlaw in hiding from the authorities. Charlotte Carmody, an independent young woman who owned a small cattle ranch, challenged Walton's control of the town by presenting herself as a candidate for justice of the peace. The drifter was Lance Poole, a stranger who rode into town, went to work on Charlotte's ranch and later joined her in the fight against Walton. The operative dramatic elements were the struggle to preserve law and order in the developing West and women's role in frontier society. There were no Indians in the story.

In a year and a half, when the story was turned into the first draft of a screenplay, some interesting changes had taken place. The female lead (her name changed from Charlotte to Orrie) is now an attorney, which helps to explain her involvement in public affairs. Ira Coffee is still an outlaw, but he was born a half-breed who lived in the area of Medicine Bow all his life. His villainy is touched with a streak of pride in his Indian ancestry and a resentment of the settlers' prejudice agains Indians. Instead of being a respected citizen, Ira has become a powerful figure in the community, helped along by a band of thugs who work with him to terrorize the town. Lance Poole is no longer a drifter. Although he has no Indian blood, he is like a brother to Ira, whose Indian mother took him in as a baby.

These factors complicate the character relationships. Orrie is fighting on behalf of the distraught sheepherders whose flocks will die if Ira does not let them use a watering hole he claims as his (it lies in a

45

On the set of *Devil's Doorway,*
the camera is being prepared for a
shot of Broken Lance (Robert Taylor)
looking out wistfully at the land of
his fathers that the government
won't allow him to keep.

valley beyond the canyon known as the Devil's Doorway. The larger question is whether Ira will continue to intimidate the townspeople. But the drama focuses on personal issues as well. Lance's love for his close friend Ira is pitted against his sense of right and wrong and his feeling for Orrie, who tries to help him see the choice he must make:

> Lance, you'll have to decide between justice and power. You'll have to make up your mind if those bewildered people who are fighting so desperately for just a little security, can go on.[37]

Eventually the sheep are driven to the water hole where, in retaliation, Ira and his men attack, killing some of the herders and throwing sticks of dynamite into the massed flocks. The townspeople steel their nerve and ride as a posse to arrest Ira and bring him back for a trial and hanging, but Lance intercedes. He knows that justice must be done; but to save Ira the shame of a public execution at the hand of the whites, Lance shoots him himself and cradles Ira's head as he dies on the mountainside he had known since he was a boy. The passing of the once proud Indian is noted sympathetically, but Lance is the only person who will miss him.

After six more months of revision and more wholesale changes, the final script was ready for the director and his production crew. As it went to the screen, the film's central character was Lance (actually Broken Lance), a full-blooded Shoshone Indian. The Barney Walton/Ira Coffee character does not appear. The film opens as Lance returns home to Wyoming from the Civil War, where he had fought valiantly with the Pennsylvania line at Mechanicsville, Antietam and Gettysburg, raised himself to the rank of sergeant major, and earned the Congressional Medal of Honor. For generations, Lance's family has enjoyed undisputed title to "Sweet Meadows," the valley behind Devil's Doorway. Now Wyoming has been organized as a territory of the U.S. and, encouraged by unscrupulous agents, homesteaders are pouring into claim the land. Lance learns that regardless of his service in the war, his Indian status legally disqualifies him from holding the claim to his ancestral home. Orrie tries to help by petitioning the legislature

and playing intermediary. In the end, rather than move to a reservation, Lance chooses to die defending his home against the stirred-up settlers and the U.S. Cavalry. The cavalry officer explains to Orrie that, in spite of the situation, they have no choice but to follow orders and suppress the Indians.

Considering possible responses that the studios might make to the declining movie attendance after the peak year of 1946, it should not be surprising that films were tailored more and more to fit the producers' ideas of what the public would buy. The development of the screenplay for *Devil's Doorway* shows an attempt to take an interesting story and alter it to enhance its appeal to post-war moviegoers.

When pre-war Hollywood movies pitted good against evil they left no doubt about which was which. During and after the war, though, films became more complex and their issues less cut and dried. The first-draft script, for example, complicated Lance's character by putting him in a position where he had to choose between loyalty (to his brother) and justice (represented by Orrie and the townspeople). The final script changed the issues somewhat, complicating them still further. Now the entire community had to realize that the law could be unjust, and they were challenged to try to set things right. Besides, although it is easy to identify the evil characters, no one is indisputably in the right. The settlers demand the water they need to survive, and Lance refuses any compromise that might lead to a peaceful resolution. Both forces are fixed in their resolve, and conflict is inevitable.

In addition, the film was made to play a theme of racial injustice that had become the basis for a series of late '40s Hollywood films such as *Intruder in the Dust* (1949) and *Pinky* (1949) about blacks, and *Gentleman's Agreement* (1947) and *Crossfire* (1947) about anti-semitism. Just as in these films about modern-day prejudice, in the final version of *Devil's Doorway* several local residents have to choose between complacency and convenience (in spite of guilt feelings) on one side and, on the other, speaking out in support of Lance and against the wicked lawyer/land agent. Orrie and her mother make the proper choice, to try

In *Devil's Doorway*, a returned Civil War hero with a Congressional Medal of Honor pinned to his uniform, Lance, is told by his father that there is trouble with the whites in the area, and that he must realize that these men would not consider him an equal, as other whites had while he was in the army.

In this original lithograph poster advertising *Devil's Doorway*, Robert Taylor appears to be as likely fighting Indians as, in fact, portraying the Shoshone Broken Lance.

to help Lance even if it brings on the criticism of the rest of the town. The bartender plays it safe and placates the incoming settlers who are likely customers for his saloon, though it means turning his back on an old friend. Zeke, the sheriff, is in the toughest spot of all. To carry out his sworn duty he must ride out with a posse against his friend Lance. His heart isn't in it, and the confrontation ultimately costs him his life.

The earlier version of the script alludes to this matter of racial injustice, but the final screenplay emphasizes the theme by making the main character a full-blooded Indian and introducing him as a decorated war hero. Thousands of black and other minority G.I.'s returned from World War II with dreams for the future similar to those Lance brought home from Gettysburg. They had also fought side by side with whites, eaten out of the same mess kits and slept under the same blankets. Many of them, as Lance, thought that prejudice would now be a thing of the past. Several phrases of dialogue in the film address this comparison directly (such as Lance's line that "perhaps a hundred years from now things will be different"). *Devil's Doorway* had the Indians play out a historical allegory on American racial issues. In a realistic and sensitive way it used the past to speak to the present.

BROKEN ARROW

Broken Arrow (1950) has been considered a watershed in terms of Hollywood's treatment of the Indian. In presenting the first truly sympathetic view of the Native American since *The Vanishing American*, the film tripped off a series of similar movies extending over the next two decades. The main characters are Tom Jeffords (James Stewart), an Indian scout and supervisor of the U.S. Mails in Arizona, and Cochise (Jeff Chandler), leader of the Chiricahua Apaches with whom Jeffords tries to talk peace. We get an idyllic image of the Indians' way of life. For example, when Jeffords falls in love with a young Indian maiden (Debra Paget), they go through a beautiful wedding ceremony followed by a traditional ride on white horses to the wikkiup that has been prepared for their wedding night. At first the gulf between this simple and virtuous life style and the violence of the young braves, who threaten Jeffords and ambush and torture a party of whites, seems incomprehensible. By the end of the film, though, after white vigilantes kill Jeffords' bride in an unprovoked attack, the audience shares his urge to seek revenge. Cochise has to convince his white friend that his side cannot win lasting peace by

continuing war. Darryl Zanuck worried that the Jeffords character might be presented as too noble for the audience to believe. Ironically, perceptive viewers might have thought that the idealized Cochise seemed even less real. The result, rather than an objective portrait of the Indians, is a reaffirmation of the older "noble savage" stereotype.

While *Devil's Doorway* may have preceded it as a preliminary presentation of the revisionist interpretation of the Indian, *Broken Arrow* captured the public mind and became one of the most popular films of the season. The film's success was especially important because of the slump that the movie business had been experiencing. Typical of the industry's behavior, a string of other sympathetic Indian movies [*Jim Thorpe, All American* (1951), *Seminole* (1953), *Broken Lance* (1954)] followed the first successful film of this kind, but the slow decline in movie attendance continued throughout the decade. Ironically, television, the reputed cause of the demise of Hollywood, gave *Broken Arrow* its most significant praise by making it one of the first feature films to become the basis for a regular TV series.

The evolution of this film was similar to the development of *Devil's Doorway*. It, too, went through a series of changes, transforming a historically factual story into a typical post World War II "problem picture" with the conventions necessary to please a broad American audience. The film had to consist of a love story and lots of shoot-em-up action, and (in the tradition of the Zanuck studio) a big and expensive Technicolor production. If it was possible to graft to this once-proven combination the kind of plea for racial understanding that had become one of the few successful movie themes since the end of the war, its likelihood of commercial success would be high.

Julian Blaustein later explained how he had come upon Elliott Arnold's book, *Blood Brother,* while searching for a story with which to break into feature film production after a career as documentary filmmaker and editorial supervisor for David Selznick. Since studios had already turned down the story because of anticipated high production costs, Blaustein tried to tighten the story and the point of view,

eventually discarding more than half of the book to concentrate on the relationship between Tom Jeffords and Cochise. This done, he was able to interest James Stewart in the project and finally to contract with Twentieth Century-Fox to produce it.[38]

Unlike *Devil's Doorway*, which was pure fiction, the film's two central characters were drawn from history. Jeffords (played by James Stewart) had been an Indian scout and superintendent of mails in Arizona in the 1860s and 70s. Historians had recorded how he had interceded with the Apaches to allow his mail riders to pass through their territory and how the traditionally savage Indians, taken with his courage and honesty, had agreed. Later he served as intermediary between one band of Apaches and U.S. General O.O. Howard in negotiating a peace treaty. Cochise (played by Jeff Chandler) was the Chiricahua Apache chief with whom Jeffords dealt— an extraordinary Indian leader known for military skill, statesmanship and farsightedness in decision-making. As usual, the studio would play up the fact that the film was based on actual events. As always, series of factors worked to shape the final product.

For one thing, there was pressure from another studio. When Twentieth Century-Fox agreed to make this film in April 1949, it bought all the rights to the novel and to the screenplay that Blaustein had worked on with screenwriter Michael Blankfort. Within a few days an MGM executive wrote to them, worried that a scripted scene in the screenplay for *Blood Brother* would duplicate a scene in a film that they were about to begin shooting. At lunch earlier that day, the two correspondents had discussed the scene, "an uncommon type of ambush," in which a group of Indians disappear into a desert background by covering themselves with sand, and the MGM spokesman had explained that it was a climactic scene of their film, "inextricably woven into the construction." The letter went on:

> As I told you, I discussed this matter with Julian Blaustein the moment I read *Blood Brother* on the 7th of April (before you people had bought the screenplay) and he gave me the impression that he agreed that the ambush was not a *vital*

As Tom Jeffords (James Stewart) rides into the Indian camp for the first time in *Broken Arrow,* he is met by the braves of Cochise, bristling with guns.

part of his story. He also agreed that it would be unfortunate for two pictures to appear in quick succession using the same device.[39]

As might be expected, the powers at Fox saw the wisdom of the request and went along.

Blaustein claimed that he "hoped to bring a documentary approach to an historical subject," and he explained how this goal influenced the casting: "By using unfamiliar faces in all but the Jeffords part, we might make them acceptable as human beings."[40]

rather than as actors going through their paces. The choice of young Jeff Chandler, who at that point was known mainly for his role on Eve Arden's *Our Miss Brooks* radio program, and Debra Paget, who at sixteen had played only a few minor roles, seemed to fit this requirement. They did, however, cause some difficulty. In reality, Cochise was an old man when these events took place, and Jeffords, who in fact went on to become Indian agent for the area after the treaty was signed, outlived him by forty years.

Apache woman's household work basket collected in the 1890s (N.J.S.M. cat. no. 15265). Note similarity to those portrayed in scene from Broken Arrow.

Chandler's Cochise, in contrast, is very much Jeffords' contemporary. Although evidence exists that Jeffords may have had a woman in the Indian camp, producer Blaustein freely admitted that the romance with the Indian maiden Sonseeray (Debra Paget) was entirely fictional. The device of the "squaw man" (the white man who marries an Indian woman) could be traced back to the earliest examples of literature about the Indians (and to several films that bore that name). Furthermore, traditional Hollywood wisdom held that a "love interest" would be important in attracting a female audience. In this case, however, the innocence and purity of the relationship and Jeffords' willingness to cut his ties with white civilization in marrying the girl seemed too contrived.

Executive producer Darryl Zanuck found one element in the film especially unconvincing. He thought that the Jeffords character seemed too sincere and self-sacrificing, and he measured such worries in commercial terms:

> in analyzing recent success and failures in pictures we have found that with very few exceptions any picture with a too noble hero is doomed at the box office. Since our picture is going to be a very costly one, we have to be practical about it, and design our hero so that he does not fall into the category of the too-noble. As presently written nobility simply oozes out of Jeffords. He is never wrong about anything. He is perfection itself, and this worries me greatly. I do not believe that this is too difficult to correct. If we get our hero off to the right start, most of the scenes later on will be colored by the character we establish for him at the beginning.[41]

Zanuck's conference notes indicate that after a prolonged discussion it was decided to make Jeffords seem less altruistic at the beginning of the film. For example, in the opening monologue Jeffords admits to a belief that all Apaches are like snakes. Only through nursing a wounded Indian boy back to health does he come to see the Indians as human beings. Later, he fails to jump at the opportunity to visit Cochise and talk peace but gradually talks himself into it. Zanuck also suggested the insertion of the scene where the townspeople try to lynch Jeffords,

only to be stopped by General Howard, who then asks that Jeffords take him to negotiate with the Indian chief.[44] The incident helps to explain Jeffords' commitment to proving the townspeople wrong; it also presages the vigilante attack that results in Sonseeray's death.

Zanuck's concern was that the film be believable to white movie audiences. Had he been worried about the Indians themselves, perhaps he would have devoted more attention to an accurate portrayal of the tribe's ritual. The moving marriage ceremony and wedding night rituals portrayed in the film are Hollywood fantasy. In addition, of course, whites played all the leading roles. But Native American activists at the time seemed to be thrown so off-balance by the sympathetic image that they did little to object to this film. In fact, Oliver LaFarge's Association on American Affairs endorsed the movie, claiming that it proved that the "American Indian must be considered a first-class citizen." As LaFarge continued, "Broken Arrow also points out to Hollywood that stereotypes can be discarded and that both Indians and whites emerge as human beings: cruel, frightened, courageous, kindly."[43]

On the contrary, instead of tearing down the stereotype, one might argue that Broken Arrow simply refurbished an old one—that of the "noble savage" enshrined by George Seitz in his Vanishing American some twenty-five years before. It may seem surprising that Zanuck's concern about the excessive nobility of the Jeffords character was not carried over to the portrayal of Cochise. Bosley Crowther of The New York Times was one of the few critics perceptive enough to see through the film: "We cannot accept this picture as either an exciting or reasonable account of the attitudes and ways of American Indians. They merit justice, but not such patronage."[44] Presumably Hollywood's current trend to compensate for some of the unfortunate images it had put forth in the past influenced Zanuck's judgment. Broken Arrow certainly bears the stamp of the post-war "problem film." Perhaps the pressbook was too bold in proclaiming that the story "shattered the barriers of color and hate."[45] But Julian Blaustein made the point more

The marriage ceremony in Broken Arrow is Hollywood fantasy.

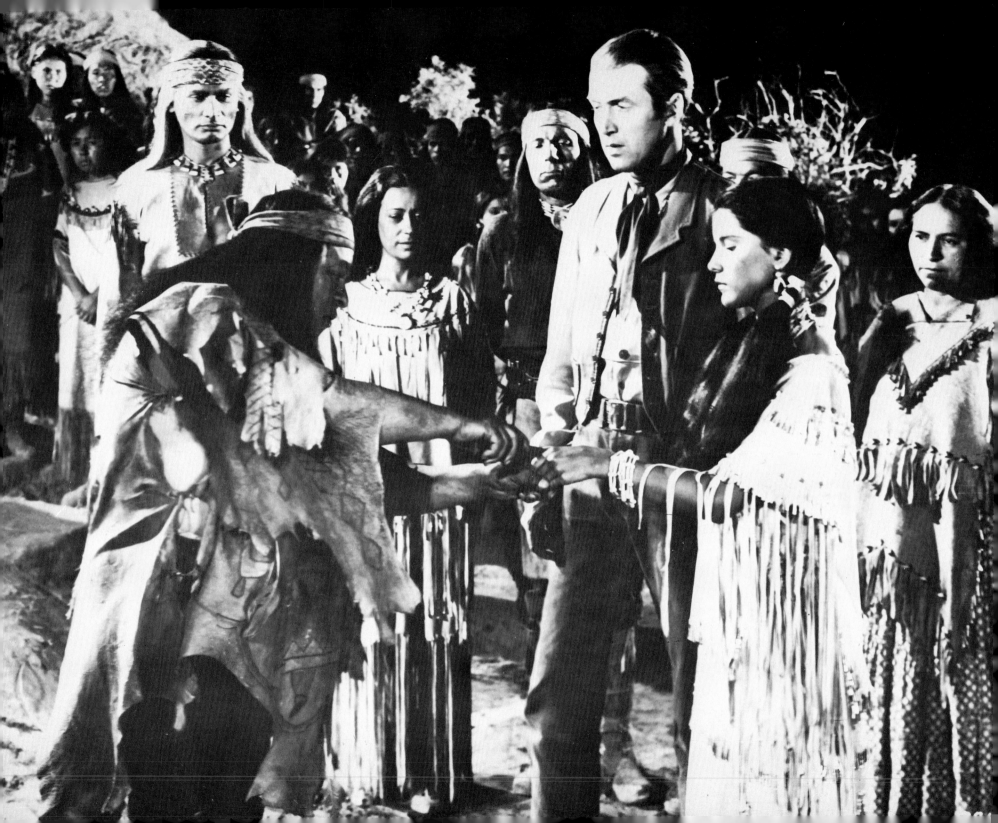

persuasively when he explained that in the film (as in society) "the only real 'heavies' are ignorance, misunderstanding and intolerance."[46]

CHEYENNE AUTUMN

Cheyenne Autumn (1964) was the last western to be directed by John Ford, a Hollywood institution long celebrated for his western films. Some of Ford's best movies, such as *Drums Along the Mohawk*, capitalized on the ferocious Indians as a device to help develop more important characters. Ford explained *Cheyenne Autumn* as his attempt to compensate for some of the earlier derogatory images he had helped to bring to the screen. As an act of penance it may have worked, as a film it did not.

The story was based on actual events of 1878-79. Two hundred eighty-six Cheyenne, the tattered remnants of a much larger group that had been forcibly relocated from its homeland to a barren and dusty reservation in Indian territory, fled the reservation and set out for home some 1,500 miles away. Mari Sandoz popularized the story and used the events and characters as the substance for her book, *Cheyenne Autumn* (1953). Nearly seventy years old, Ford developed the project with producer Bernard Smith. They brought in an all-star cast of non-Indians (Richard Widmark, Carol Baker, Karl Malden, Sal Mineo, Dolores Del Rio, Ricardo Montalban, Gilbert Roland, Arthur Kennedy, Patrick Wayne, Elizabeth Allen, John Carradine and Victor Jory, with cameo appearances by James Stewart and Edward G. Robinson) and convinced Warner Brothers studio to cooperate in the production.

The problems in making the film were monumental: first, the logistical problems of moving hundreds of actors, technicians and support people with their equipment to three distinct locations hundreds of miles apart; then, budgetary problems and the subtleties of financial negotiation between the independent producers and the studio. Finally, in response to mounting costs and concern about the box-office appeal of the finished product, studio people went to work in secret tightening and shortening the film without letting Ford or Smith know until it was done.

"Will you take the blinders off for just once," Captain Archer (Richard Widmark) begged the Quaker school teacher (Carol Baker) in the opening sequence of *Cheyenne Autumn*. The line refers to her open-hearted (and perhaps naive) sympathy for the Indians preparing for their long march homeward. Archer sees their plight, but he thinks he understands his duty as well. His love for this woman—he scratches a marriage proposal on the blackboard at the end of the scene—complicates his situation further. But the reference to blinders extends beyond the characters in the film. It speaks to the personal perceptions of director John Ford and the cultural blinders that have always helped to influence the Hollywood product.

In 1963 as Ford and his crew labored on location filming *Cheyenne Autumn*, *Esquire Magazine* sent out a young writer to observe Ford at work. The writer was Peter Bogdanovich, who has become a significant filmmaker in his own right (for example, *Last Picture Show*, *Paper Moon*) and one of Ford's most perceptive biographers. Ford explained his current project and its focus on Native Americans:

> I had wanted to make it for a long time. I've killed more Indians than Custer, Beecher and Chivington put together, and the people in Europe wanted to know about the Indians.[47]

In fact, Ford's films were not so laden with dead Indians as many of the "B" westerns cranked out to fill the lower half of Hollywood's double bills. His trio of cavalry epics—*Fort Apache* (1948), *She Wore a Yellow Ribbon* (1949) and *Rio Grande* (1950)—were certainly less than sympathetic. But several others, such as *Wagonmaster* (1950), which compared the Indians to the Mormons as social outcasts in an intolerant society, and *The Searchers* (1956), which emphasized one white man's irrational hatred of the Indians, left room for understanding. *Cheyenne Autumn* went further. As Ford told Bogdanovich:

> There are two sides to every story, but I wanted to show their [the Indians'] point of view for a change. Let's face it, we've treated them very badly—it's a blot on our shield; we've cheated and robbed, killed, murdered, massacred and everything else, but they kill one white man and, God, out come the troops.[48]

57

The real Cheyenne chiefs Little Wolf and Dull Knife in photograph taken prior to 1877, the year of their homeward trek portrayed in Cheyenne Autumn. (Courtesy of National Anthropological Archives)

Whenever they have tried, Hollywood filmmakers have always found it difficult to present the Indians' "point of view." Despite John Ford's avowed intention, *Cheyenne Autumn* would be no exception.

The events of the Cheyenne trek north in 1878-79 provided the framework for Sandoz' book. Using flashbacks and other techniques, she had actually chronicled the highlights of the Cheyennes' experience with the white man since the 1840s. The extensive notes John Ford and his son Patrick prepared influenced James R. Webb's screenplay, originally titled "The Long Flight." However, the film retained the basic elements of the true story: the escape from the reservation, the confrontations with pursuing cavalry, the division of the Indians into two groups under Little Wolf and Dull Knife, the capture of Dull Knife's band and its eventual breakout from Fort Robinson and, finally, the survivors' reunion on a new reservation.

Alteration of some of the historical events seemed necessary to establish the characters and the situation. At the opening of the film, for example, the Cheyenne turn out for the long-expected visit of a Congressional Committee to whom the sick and underfed but proud Indians expect to present their grievances. All day long they stand silently in the hot sun in front of the Indian Agency office, only to learn the committee has changed its plans and passed them by. The episode is invented, but the dramatic intent is clear—to show the Indians' mistreatment as well as their struggle to maintain their human dignity.

Several new characters were introduced and others drastically revised on their way to the screen. In spite of Ford's desire to portray events through the Indians' eyes, most of the changes soften the film's criticism of the whites. Carol Baker, for example, plays Deborah Wright, a Quaker school teacher who works with the children on the reservation. Deciding that the little ones need her care on the long march, she vows to go with them. Richard Widmark, as Captain Archer, plays the well-intentioned military man, in contrast to his commanding officer who is more than willing to earn advancement over the bodies of innocent Indian women and children. The film continues its focus on

Spanish woman (Dolores Del Rio) dramatizes the infertility of the barren soil at the Cheyenne reservation in Indian territory. Sal Mineo and one of the Navajo extras look on from the tepee door in Cheyenne Autumn.

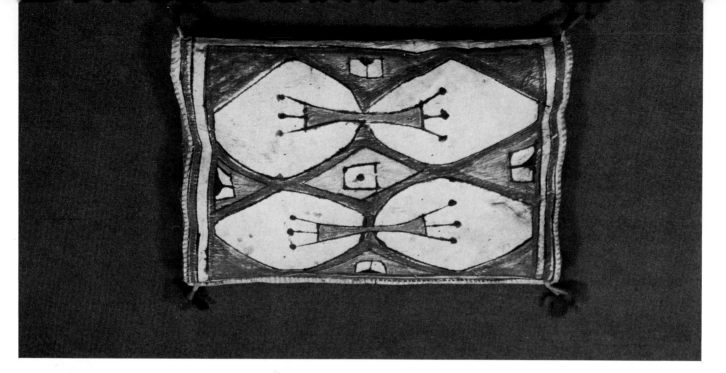

Cheyenne awl cushion probably made in nineteenth century (Courtesy of American Museum of Natural History cat. no. 50/50). The clothing, housing and most other equipment of Plains groups such as the Cheyenne were made from buffalo and other animal hides prepared by women and then sewn using an awl, a type of punch.

the developing romance between the captain and the schoolmarm, and the viewer sees much of the Indians' story through their eyes. It also explains why these whites and others felt as they did. One young soldier (Patrick Wayne) tries to avenge the death of his parents, and a cowboy who is sick of hearing the old Indian War veterans brag about their exploits wants a scalp to show off. The Quaker woman's beliefs commit her to the Indians, and Archer's sympathy for them seems to grow in ratio to his love for her. The characters of Archer, Wright and the others provide a bridge through which largely white audiences can relate vicariously to the Indians' experiences. In the process, however, their presence also implies a much more genuine concern for the Indians' well-being than that which had existed.

This becomes still more clear with the introduction of Edward G. Robinson in the role of Secretary of the Interior Carl Schurz. Rather like a nineteenth century Freedom Rider (after all, the film is being produced in the midst of the 1960s civil rights movement) Archer takes a few weeks personal leave and travels by train to Washington to plead the Cheyennes' case. Though too late to avert the bloodbath at Fort Rob-

inson, Schurz is so touched that he travels to the frontier to negotiate the Indians' surrender and to guarantee their relocation on a new reservation. Sandoz' account does not mention Schurz specifically. In fact, no emissary from Fort Robinson existed, and Schurz is known to have approved the order to have the Indians moved south again—a decision that precipitated their heroic break for freedom.

At various points throughout Sandoz' broken narrative, comment is introduced about the country's reactions—especially the western populace—to the news of the Indians' march. Over the thirty years since mid-century, the Cheyenne, like the other tribes, had been broken from a fierce and powerful people to a pathetic band searching only for subsistence for their women and children. But memories of the past had bred hysteria (not unlike the Cold War fright of the 1950s and early 1960s) that the press fed upon and exaggerated. The film integrated some of this in a provocative way—showing how some newspaper editors eventually shifted from anti-Indian to a position of grief for the noble red man, hoping it would sell more papers.

Less effective, however, was an extended comic

sequence in Dodge City that featured Jimmy Stewart as Wyatt Earp and Arthur Kennedy as Doc Holliday, both too involved in a barroom poker game to give much credence to the fears the people expressed. "Have you ever read anything true in that paper?" Stewart asks a particularly animated customer in the Dodge City saloon. To the extent that it dramatized the settlers' unsupported fears, the scene had a purpose, but as comic relief and a vehicle for James Stewart, it served more as a distraction from the Indians' story.

The vast proportions of the project and erroneous estimates of its cost also took their toll on the finished film. Early budget projections greatly underestimated the costs to be involved in the production. The two million dollar direct cost to which Bernard Smith and the Warner studio had originally agreed jumped a few months later to over five million. Some of this increase reflected the decision to produce in a more expensive Super Panavision process, but more was because, in John Ford's absence, early budget planners had to guess how he would operate. An interoffice memo from the Warners' file at the University of Southern California suggests a few of the differences between the June 21, 1963, "flash budget" and the "estimated cost to complete" the film as of December 4, 1963.[49]

Item	June 21	Dec. 4
set construction	$ 75,000	$279,000
props and handling	146,000	322,000
men's wardrobe	32,000	· 125,000
transportation	179,000	248,000

Many of the excess expenses accrued from filming at three distinct locations, as well as on the studio sound stage. Management problems were evident, too. "We are getting an enormous number of props which we do not need, including rental props which are costing a lot of money," one studio employee reported from Monument Valley. "We are shipping stuff back as fast as it arrives."[50] One way to try to cut expenses was to closely watch living costs for the crew and associated personnel on location. Living space for the publicity people was particularly tight,

for example, and when Peter Bogdanovich decided to bring along his wife, others cramped in a single trailer began to complain.[51] Smith and Ford felt the pressure because their share of the profits would begin to accrue only after the income from the picture had covered all the costs. At several points during the production process they agreed to eliminate scene after scene to cut expenses, especially those scenes that had to be filmed on location, and they trimmed several days off the location schedule.[52] They cancelled plans for the Yellowstone River location that would have shown the Indians' final return to their homeland. Here is at least one specific instance where the financial problems compromised the film's dramatic impact.

Still unsatisfied, studio chief Jack Warner put editors to work behind the scenes cutting the three-and-one-half-hour movie before it was released. Warner's assistant, sensitive to the situation, warned that these instructions "should be kept confidential as far as the Ford-Smith group are concerned."[53] In the end, cuts went even deeper, eliminating half of the Dodge City sequence and getting the overall length down to a (still long) two-and-one-half hours.

John Ford had accomplished an announced desire to make a film sympathetic to the Indians, but with considerable difficulty. Most of the critics responded better to the Dodge City sequence (even in its shortened form) than to the rest of the film. They had difficulty understanding the Indians' view of events, despite (or perhaps because of) the major white characters invented to make the story more comprehensible and more entertaining.

Finally, *Cheyenne Autumn* dramatically illustrates how even sympathetic films on Native Americans have failed to appreciate the Indians' concerns fully. By substituting his beloved Monument Valley for the parched plains, by altering traditional costumes and styles of hair dress for no evident reason and by using all non-Indians in major acting roles, Ford showed his lack of respect for obvious fact and for native custom. Some thought that hiring hundreds of Navajo to play the forefathers of the Cheyenne was the worst slap at the Indians.

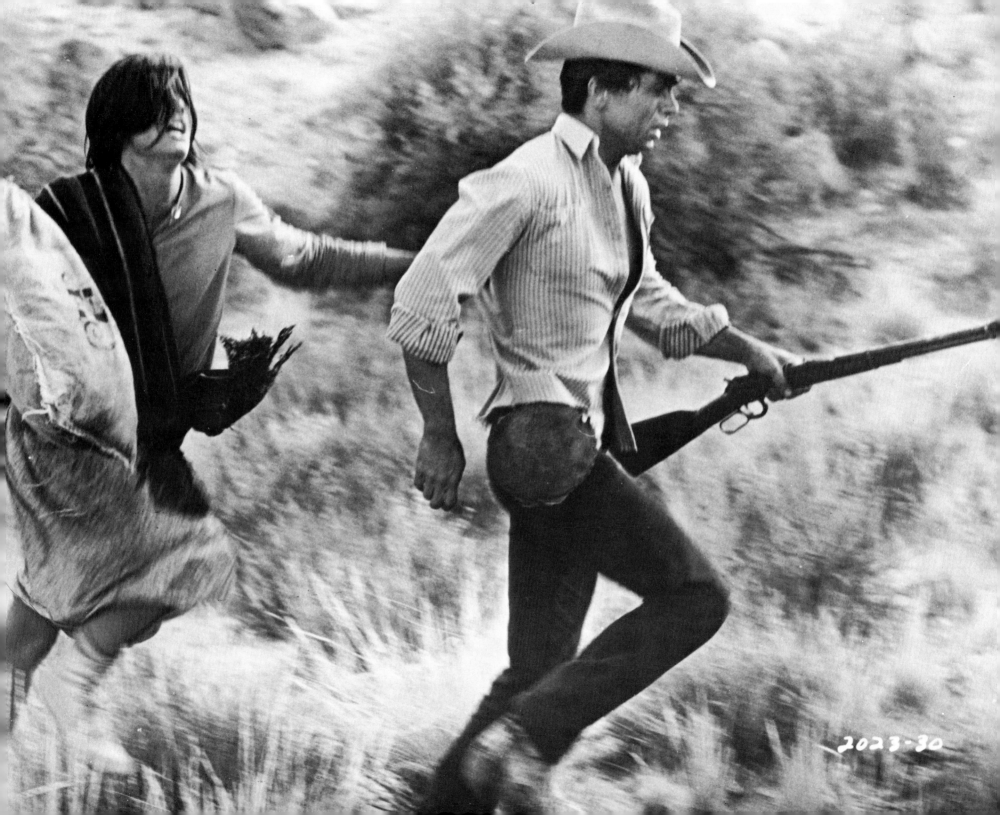

TELL THEM WILLIE BOY IS HERE

Tell Them Willie Boy Is Here (1969) was based on the true story of a young Paiute Indian who became the subject of an exciting cross-country chase in southern California in 1909. Actually, it was as much about the McCarthyism of the 1950s and the youth culture of the 1960s. Although the story of the real Willie Boy had become local legend, its overtones gave it broader significance. A young Indian shoots and kills the father of the girl he wants to marry, then flees with her into the desert. In the course of a manhunt that covers over 500 miles of arid landscape, the girl is shot to death and, eventually Willie Boy dies as well. What made the case more interesting was President Taft's scheduled visit to the area. In response to unfounded rumors of an assassination attempt, a major effort was made to hunt down the Indian. The incident gave the aging Indian fighters of the neighborhood, whose memories of the wars against other tribes were fading, a chance to get their juices running again, to rationalize their bloodlust as civic duty. Abraham Polonsky, who wrote and directed the film, had a special feeling for the story. It was one of the first films he had been able to work on without using an alias since he had been blacklisted during McCarthy's Hollywood inquisition in the 1950s. The sheriff's (Robert Redford) willingness to abandon his sense of justice and his respect for Willie Boy (Robert Blake) as an individual, giving in to social pressure in killing the Indian, is reminiscent of the path some Hollywood notables took when called on to implicate their friends and colleagues in the so-called "communist conspiracy." Many young people in the 1960s could also find parallels between Willie's experiences and their interpretation of America and Vietnam.

Tell Them Willie Boy Is Here (1969) was the second film Abraham Lincoln Polonsky directed—his first had been some twenty years before. Caught in the Hollywood red scare of the 1950s, Polonsky's refusal to answer questions before the House Committee on Un-American Activities led to his being blacklisted. With hundreds of other directors, writers and actors denied the opportunity to practice their craft publicly for at least the next decade, Polonsky went underground and wrote scripts for television shows under an assumed name.

By 1969 Polonsky had emerged from the blacklist with a screen-writing credit for *Madigan* (1968), so his decision to direct a film based on Harry Lawton's book, *Willie Boy*, reflected more than simply a desire to get back into the business. In an interview published in 1970 the filmmaker explained that initially he had been cool to the story because he saw it as a contrast between the Old West and the New, neither of which interested him very much. Later he came to understand the story's contemporary significance:

> It had to do with most of the young people I knew today, living in a transitional period and being driven by circumstances and values they couldn't control. And at that point, I thought it would be an interesting story to do, because then I could play around with this romantic investment we have in the past, along with a lack of comprehension for the realities of the present, and show these two things pushing one way and another.[54]

Polonsky's motives went beyond a special feeling for the Indians. He saw the forces in the story as "a general human situation," a set of ideas that his audiences might easily relate to the charges of racism and genocide that were being applied to America's urban ghettoes and to her policy in Vietnam. It was "fundamental to human history," he said, and had to do with the advance of so-called "civilization" wherever it was found:

> Civilization is the process of despoiling, of spoilation of people, which in the past we considered a victory, but we now suspect is a moral defeat for all.[55]

Such observations about the frontier and the myths associated with it were not unique. As Christopher Lasch has most recently explained in his *The Culture of Narcissism* (1979), the frontiersman excused his lapses into sadism and brutality—especially as they related to experiences with the Indians—by rationalizing the goal as a "peaceful, respectable, church-going community safe for his women and children."[56]

63

In Polonsky's film the illogic and the tragedy of such rationalizations are brought to the surface.

Indian-movie fans may be disappointed that most of the costumes the Indians in *Willie Boy* wore might be mistaken for street dress of the 1960s or 1970s. Moreover, at the beginning of the film when Willie returns to the reservation to claim his bride, he jumps off a modern-day freight train that the director had made no effort to transform to its turn-of-the-century equivalent. Though these anachronisms may appear to undermine the film's illusion of reality, they underscore the allegorical nature of the story and the timelessness of its message.

In the process of making his statement (as both writer and director he had more than usual creative control), Polonsky made some interesting adaptations of the story and characterization. He portrayed Liz (Susan Clark), a well-educated young woman from the East appointed to serve as supervisor of the Indian reservation, as a progressive liberal. She is concerned about the physical well-being of her charges, but seeing herself as their superior, she cannot comprehend their psychological or spiritual needs. Katherine Ross, hardly a Native American type, plays Lola, the subject of Willie's attentions. Polonsky explains that he shaped Lola as a girl trying to take on white ways, partly because of the difficulty Ross had in making herself believable as an Indian.[57] Robert Redford plays Coop, the sheriff, in an interesting way—as obviously capable but strangely unsure of himself. On several occasions he seems to disapprove of the other white men's prejudice against the Indians, partly because he respects Willie as an individual.

The real Willie's body was found in the desert where he had killed himself. (The legend presumes that he had earlier killed the girl because she had refused to run further with him. The film leaves us wondering about how Lola died. Polonsky says that he

In the opening sequence of *Tell Them Willie Boy Is Here*, Willie (Robert Blake) is shown hitching a ride on a freight train. By making no effort to disguise the train as a turn-of-the-century model, director Polonsky emphasized that the symbolic nature of his story could apply to any time.

preferred to think of her as committing suicide rather than slow down Willie's flight.) The film, however, handles Willie's death far more dramatically. As Coop tracks him down—finally in a one-on-one situation—Willie keeps his adversary at bay. Knowing that his end is near (symbolically he had put on his father's ghost shirt along the way), Willie wants to die as a man and as an Indian. Eventually the sheriff closes in, orchestrating the final confrontation so that he does not have to shoot to kill. He offers Willie the opportunity to turn himself in, but, after a pause, Willie levels his gun and Coop must fire. His later discovery that Willie's gun was empty and that the Indian had tricked him into making the fatal shot upsets the sensitive lawman.

From the viewpoint of Polonsky's perceived intention, a relatively minor character in the film should be considered closely. Calvert (Barry Sullivan) is an old Indian fighter. Bored with life as he lives it, he sees participating in the posse chasing Willie as a way to regain the excitement of his youth. Calvert was a friend of Coop's father, who had also fought the Indians. He fondly reminds the young sheriff about the time "your daddy and me followed a party of Comanche two hundred miles into Mexico" and, "we brought back six scalps that time."

The whites never indicate consciousness of the presence of a trio of Indian policemen riding with the posse, even when they sit around the campfire swapping stories of their old exploits. Quiet at first, the policemen begin to sympathize more with Willie's plight, especially after Lola's body is found. Though they do not question the sheriff's authority or stand in his way, at the end of the film they disobey his order to bury Willie's body. Instead they prepare a pyre and burn him in a manner (the viewer presumes) usually reserved for chiefs. The symbolism here lies in their idealization of their dead brother. But there is a practical reason for burning the body as well. The Indians wanted to deny Calvert's friends the chance

Three Indian policemen take a last look at Willie after Coop (Robert Redford) has shot him down in *Tell Them Willie Boy Is Here*. They then prepare a funeral pyre and burn his body.
(Courtesy of the Museum of Modern Art/Film Stills Archives)

to bring back Willie's scalp as they had returned with the scalps of past Indian victims. As Polonsky explained:

> Now he's burned beyond salvage and there's nothing to bring back except cinders. So the posse rides in and starts pulling the fire apart— a boot, a shoe, an ear, *anything* to bring back. And they're dancing around this fire, trying to find something.

One of them demands, "God damn it, Coop, what've we got to show for it? What will I tell 'em?" And Coop replies: "Tell 'em we're all out of souvenirs."

Here was Polonsky's point. No souvenirs of past glories, whether in the form of scalps, Congressional Medals of Honor or memories of past wars, should confuse or stir up emotions over present issues. Clearly, Polonsky's film sympathetically portrayed the Native Americans as of 1909 when the white man's self-image was still bound to his feeling of power over the Indians. It also had a broader message.

Willie's wearing his father's ghost shirt symbolizes a major theme in the book that the film only partially develops. Having fallen away from traditional Indian ways, Willie was driven back to them by realizing that white society would not accept him as an equal. Killing Lola's father was a reversion to the tribal custom of marriage by capture, and the sympathy of the Indian policemen was based on their recognition that the white posse neither understood nor cared to understand the Indians' ways. Although the funeral pyre served Polonsky's purpose as a sign of respect, according to the book Willie's body was burned primarily because it had begun to decompose.[58]

The reviewers, generally impressed with *Willie Boy*, were less sanguine about the commercial prospects of a film that seemed to sacrifice entertainment values to further an intellectual point of view. Interestingly, the success the film enjoyed in Europe seemed to offset the disappointment experienced at the domestic box office. As one reviewer correctly predicted, "abroad it should be a smash" for its radical intellectual content and for its idea, common to other European films of the 1960s, "that our present civilization must be destroyed [as in the flames of Willie's funeral pyre] and be built anew."[59]

The weapons of the Chemehuevi Indians portrayed in Tell Them Willie Boy Is Here were actually used more for hunting game than for warfare. This painted bow (N.J.S.M. cat no. 15309) was collected in the 1890s.

The Paiutes' adaptation to desert life included use of tightly woven baskets covered with pine pitch to make them waterproof. This Paiute water bottle (N.J.S.M. cat. no. 7092) was collected in the early 1900s.

LITTLE BIG MAN

Little Big Man (1970), a successful and amusing film, sets out to tell the story of clearing the Indians from the plains from the Indians' point of view. Actually, however, the protagonist is a white man, Jack Crabb (Dustin Hoffman), and the viewer sees the events through his eyes rather than the Indians'. Jack, an unlikely 121 years old, has vivid (if questionable) memories of being raised by the Cheyenne after his parents were killed during another tribe's attack. He also claims to be the only white survivor of Custer's "last stand." An endearing old Cheyenne chief named Old Lodge Skins (played by Native American Chief Dan George) adopts Jack as his grandson. Old Lodge Skins and other members of the community around him create a quaint and basically peaceful image of Indian life. In retaliation for a raid on their camp, for example, the Indians attack the whites, but they seem more interested in teaching a lesson than in leaving a trail of death and carnage. The film uses satirical humor to soften the "noble savage" stereotype, but the commercial demands of the Hollywood medium are also evident. One especially important factor was the contemporary feeling about the role of America in Southeast Asia. Influenced by the realization that the age group that most often went to the movies was also the group that most vocally opposed the war, the filmmakers created a Vietnam allegory that portrayed many attitudes and some specific images related directly to controversial current issues.

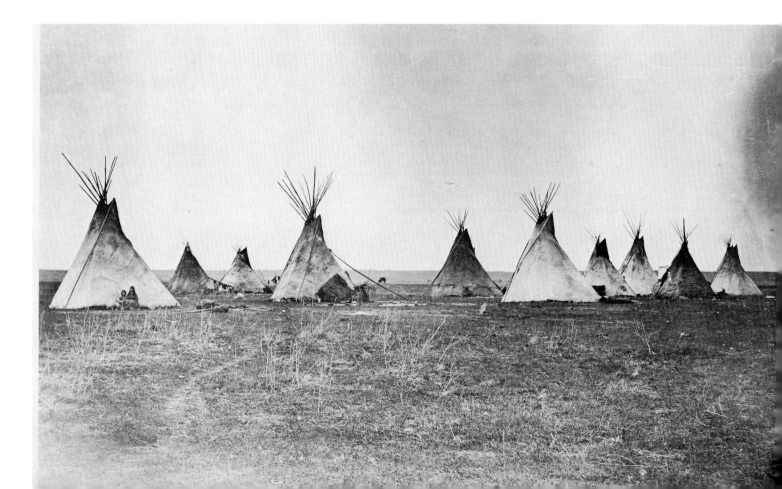

A Cheyenne camp of ca. 1867-74 photographed by William S. Soule. (Courtesy of National Anthropological Archives) Little Big Man *is one of the few Hollywood films to show the unprotected nature of Plains Indian camps and the havoc which a dawn attack by the cavalry could create.*

"*Little Big Man?* It's a damned farce." Iron Eyes Cody, famed Native American actor and consultant to many film producers on tribal customs and traditions, commented tersely when interviewed in Hollywood earlier this year. To what extent does the film succeed in presenting the Indians as real human beings (not the stoic stereotypes in so many earlier films), and to what extent does it, as Cody suggests, use the Indian and abuse history to create a commercially successful movie?

The film, based on Thomas Berger's novel of the same name, tells the fanciful story of Jack Crabb, a leather-faced, 121-year-old antique with memories of life on the frontier during and immediately after the Civil War. As Crabb remembers it for an oral historian and his tape recorder, Cheyenne Indians had captured his sister and him after a band of Pawnees attacked their wagons and murdered their family. We first view the Cheyenne through the eyes of the two youngsters, especially Crabb's sister Caroline, who escapes into the night certain that nothing she might run into could be worse than the Indians who would surely rape and molest her before morning.

But Jack learns differently. The Cheyenne treat him as an honored guest (roasting a dog for his breakfast). They teach him their ways and accept him as one of their own. The group's leader, who accepts young Jack as his grandson, is presented as an endearing character. Chief Dan George, a member of the Squamish tribe from British Columbia, who plays the role, makes it easy to believe the press stories describing the special relationship that developed between him and Dustin Hoffman during the months of filming. Eventually the boy saves the life of a young Indian, wins the name Little Big Man, and becomes a full-fledged member of the tribe—qualified to be known by the name the Cheyenne reserve for themselves, "a human being."

Where does the farce come in? The lead character in this film about Indians is a white man. We meet the Indians, but we never see completely from their perspective. In part, this stems from the limitations of the film medium. As John W. Turner argues in a recent article in *Literature/Film Quarterly*, the film

A young Jack Crabb (Dustin Hoffman) and Old Lodge Skins (Chief Dan George) in the Cheyenne village in *Little Big Man.* (Courtesy of the Museum of Modern Art/Film Stills Archives)

Costuming in Little Big Man *was more accurate than in most Hollywood films. This Plains girl's dress (N.J.S.M. cat no. 30.6) was made in the late 1800s or early 1900s.*

does not allow the expression of subtle ideas and values as easily as the novel.[60] A voice-over in the film explains that the chief, Old Lodge Skins, taught young Jack everything he knew, but on the screen we see only the skills (such as hunting and tracking) he learned. Attitudes and beliefs are difficulty to portray visually. It takes Mr. Merriwether, the con man and snake oil salesman, to point out sarcastically that the Indians gave Jack "a vision of moral order in the universe." Rather than generalize about the Indians' mystical relationship with their environment, the film tries to define it incrementally in a series of incidents. The film reduces Old Lodge Skins' communion with the Great Spirit to a few dreams in which he sees Jack playing with a soda fountain shaped like an elephant's head, or sleeping with three wives at once. The film prepares us to hear the great wisdom that the old man has to offer, only to have him solemnly comment on the sexual unresponsiveness of a white woman he had once. The humor of all this accounts for part of the film's charm, as well as its commercial success; but it is also central to the way in which the film deals with the stereotypic image of the Indian.

Plains Indian groups, such as the Sioux and Cheyenne portrayed in Little Big Man, *lived nomadic lives. When frequently moving camp, possessions were carried in parfleches, folded hide containers, such as this one (N.J.S.M. cat. no. 42.1) which is elaborately painted.*

Thomas Berger's novel brilliantly satirizes the Indians as well as the whites, but, unlike the film, it also recognizes that both had human vices and virtues. Ralph and Natasha Friar in *The Only Good Indian: The Hollywood Gospel* clearly point out the differences between the novel and the film:

> The Cheyenne in the novel are not just a bunch of noble innocents in isolation, just as the whites are not an isolated bunch of corrupt individuals. All of them are individuals who, in their own way, do all the things people are liable to do in the midst of war, poverty, corruption, greed and ignorance.[61]

If the film aimed to show the Indians as they really were, avoiding the noble as well as the vicious stereotypes, we might have expected to see at least a few Indians who did not act as noble innocents. As it was, the film presented a *Broken Arrow*-style noble savage stereotype, then proceeded to soften the image with humor. The Indians are less noble if we can laugh at them and, more important, if they can laugh at themselves. Satirizing the gunfighter, the minister's wife and the cavalry general is biting and effective, but poking fun at the Indians loses something—especially for white audiences. Everything many of them know of real Indian life and society is what Hollywood has seen fit to show them.

In interesting and amusing ways the film shows how the unpredictabilities of frontier life transform people. The sensuous minister's wife, who undertakes to teach Jack the Bible, winds up a prostitute who offers to brighten his afternoon; Wild Bill Hickok hangs up his guns and settles down, only to wind up kissing the boot of some cowpoke at a barroom poker table. Jack Crabb, though, hardly changes at all. After the Washita River Massacre, in which his wife and newborn son are killed, Jacks hit the bottle and becomes a hermit for a time, but he fails to recognize (as one might expect of a character who lived in both cultures) that the fate of Indian civilization has been sealed.

Perhaps the film's ending indicates most clearly how its humor and other entertainment values detracted from any statement it might have made.

After the Indian victory at Little Big Horn (a victory, by the way, credited to Jack rather than to the Indians), Old Lodge Skins senses that his people's days are numbered—they had won the battle but they could not win the war. Imagining that his time is near, the old man climbs a nearby mountain to die. This might have been the ultimate ennobling experience for the old Indian in mystical communion with the environment. He dances his dance, prays his prayer, lies down on his special buffalo robe and closes his eyes, but continues to live. Offering the excuse that "sometimes the magic works and sometimes it doesn't" he walks down the hill, again discussing the qualities of his newest wife. By keeping Old Lodge Skins alive and avoiding an unhappy (and therefore unpopular) ending, the filmmakers compromised the dramatic structure of the novel in which the old man's death dramatizes the end of life as the Indians know it.

Finally, *Little Big Man* is loaded with allusions to the Vietnam experience that was tearing apart American culture when the film was produced. Like another sympathetic Indian film of that year, *Soldier Blue*, the film played on the headlines of 1970 and the audience's sensitivity to the issues of the Vietnam war. The crazed General Custer condoning the killing of women and children and the blind obedience the soldiers shared to their obviously deranged commander reflected stories reported daily out of Southeast Asia. The use of terms like "rubbed out" and the implication that the whites committed genocide against the peaceful and defenseless Native Americans were unmistakable allusions to the present. Specific images used in the massacre scenes, such as a young girl running through the village with her dress on fire, evoked shockingly similar images news cameramen had captured overseas. If *Little Big Man* was a farce, as Iron Eyes Cody thought, it was also a vivid comment on current affairs. Both factors helped to make it a commercial success.

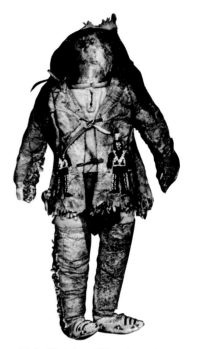

Little Big Man differs from the majority of feature films in portraying Indian children. This doll (N.J.S.M. cat. no. 11114) was the toy of a Sioux girl in the early 1900s.

This shot from *Little Big Man*, showing a young Indian girl running for her life with her dress on fire, is shockingly similar to the news photographs that came out of Vietnam.

Notes

1. "Closed Shop is the Reward for the Indian," *New York Herald Tribune*, June 4, 1939.
2. "Indian Guild Sees Little Progress in Acting Demands," *Hollywood Reporter*, September 17, 1979.
3. "Rosebud Sioux Defend CCF's *Horse*; Indians-Turned-Critics Their Old Foes," *Variety*, May 6, 1970. For discussion of the A.I.M. protest see Ralph and Natasha Friar, *The Only Good Indian . . . The Hollywood Gospel* (N.Y., 1972), p. 115.
4. Robert F. Berkhofer, Jr., *The White Man's Indian: Images of the American Indian from Columbus to the Present* (N.Y., 1978), p. 103.
5. John G. Cawelti, *The Six-Gun Mystique* (Bowling Green, Ohio, 1978), p. 38.
6. Legal Document signed by D.W. Griffith and Robert Goldstein, August 7, 1916, D.W. Griffith Papers, Museum of Modern Art.
7. Zachariah Chaffee to D.W. Griffith, May 25, 1920, and Griffith's reply, June 20, 1920, D.W. Griffith Papers, Museum of Modern Art.
8. Henry Johnston to D.W. Griffith, November 22, 1923, D.W. Griffith Papers, Museum of Modern Art.
9. Mrs. Charles White Nash to D.W. Griffith, February 25, 1924, D.W. Griffith Papers, Museum of Modern Art.
10. William K. Everson, "D.W. Griffith's Golden Years: 1909-1924," New York Theater Program Notes (1962), Museum of Modern Art.
11. Robert W. Chambers' manuscript reply to critical review of *America*, (no date), D.W. Griffith Papers, Museum of Modern Art.
12. *The Vanishing American* Souvenir Program, New York City Performing Arts Research Library, Lincoln Center.
13. Zane Grey, *The Vanishing American* (N.Y., 1925), p. 38.
14. M.C. Lathrop, "Story Synopsis and Comment," April 8, 1923, Paramount Collection, Academy of Motion Picture Arts and Sciences, Beverly Hills, Ca.
15. *Ibid.*
16. Preliminary draft of script for *The Vanishing American*, (no date), Paramount Collection, Academy of Motion Picture Arts and Sciences, Beverly Hills, Ca.
17. For a complete analysis of the production of *I Am A Fugitive From A Chain Gang* and that film's influence on the Warner Brothers films of social consciousness see this author's volume in the University of Wisconsin Press Screenplay Series forthcoming in 1981.
18. See Douglas Gomery, "Rethinking U.S. Film History: The Depression Decade and Monopoly Control" *Film and History*, X (May 1980), pp. 32-38.
19. Memo, Bob Presnell to Hal Wallis, July 13, 1943, Warner Brothers Collection, University of Southern California.
20. Memo, Hall Wallis to Alan Crossland, October 9, 1943, Warner Brothers Collection, University of Southern California.
21. *Ibid.*
22. *Ibid.*
23. *Massacre* Pressbook, Performing Arts Research Collection, New York Public Library at Lincoln Center.
24. *Ibid.*
25. *Ibid.*
26. Memo, Darryl F. Zanuck to Earl Carroll, Ray Griffith, Kenneth McGowan, Nunally Johnson, Gene Markey, Lawrence Schwab, and Harold Wilson, March 3, 1937, Story Editor's Correspondence File, Twentieth Century-Fox Archives, Hollywood, Ca.
27. Darryl F. Zanuck Comments on First Draft Continuity of December 2, 1938, dated December 30, 1938, 9 pp. Story Editor's Correspondence File, Twentieth Century-Fox Archives, Hollywood, Ca.
28. Conference Notes (on Temporary Script of March 11, 1939), dated April 5, 1939, 11 pp. Story File, Twentieth Century-Fox Archives, Hollywood, Ca.
29. *Ibid.*
30. Captain Lloyd Morris to Col. Jason Joy, June 27, 1939, Story Editor's Correspondence File, Twentieth Century-Fox Archives, Hollywood, Ca.
31. Memo, Hal Wallis to Bill Guthrie, May 14, 1941, Warner Brothers Collection, University of Southern California.
32. Memo, Aeneas MacKensie to Hal Wallis, May 13, 1941, Warner Brothers Collection, University of Southern California.
33. *Ibid.*
34. Memo, Hal Wallis is to Robert Fellows, June 10, 1941, Warner Brothers Collection, University of Southern California.
35. Memo, Melvin Levy to Robert Fellows, April 30, 1941. See also Howard Koch to Walter MacEwen, February 27, 1941, Warner Brothers Collection, University of Southern California.
36. Memo, Lee Ryan to Bob [Fellows], no date, Warner Brothers Collection, University of Southern California.
37. *Devil's Doorway* Draft Script, May 20, 1948, MGM Collection, University of Southern California.
38. "Indians' Culture Captured in Film," *Los Angeles Times*, May 21, 1950. Clipping File, Academy of Motion Picture Arts and Sciences, Beverly Hills, Ca.
39. Letter to Darryl F. Zanuck, *Broken Arrow* Story File, Twentieth Century-Fox Archives, Hollywood, Ca.
40. "Indians' Culture Captured in Film," *Los Angeles Times*, May 21, 1950, Clipping File, Academy of Motion Picture Arts and Sciences, Beverly Hills, Ca.
41. Conference Notes on *Broken Arrow* Script, June 1, 1949, Story File, Twentieth Century-Fox Archives, Hollywood, Ca.
42. *Ibid.*
43. *Broken Arrow* Pressbook, Performing Arts Research Library, New York Public Library at Lincoln Center.

44. Review of *Broken Arrow*, *The New York Times*, July 21, 1950.

45. *Broken Arrow* Pressbook, Performing Arts Research Library, New York Public Library at Lincoln Center.

46. "Indians' Culture Captured in Film," *Los Angeles Times*, May 21, 1950, Clipping File, Academy of Motion Picture Arts and Sciences, Beverly Hills, Ca.

47. Peter Bogdanovich, *John Ford* (Berkeley, 1968), p. 104.

48. *Ibid.*

49. See Memo, Charles F. Greenlaw to Roy J. Obringer, December 26, 1963, Warner Brothers Collection, University of Southern California.

50. Memo, Russ Saunders to Charles F. Greenlaw, October 17, 1963, Warner Brothers Collection, University of Southern California.

51. *Ibid.*

52. See, for example, Memos from Bernard Smith to Charles Greenlaw, October 30, 1963, and November 15, 1963, Warner Brothers Collection, University of Southern California.

53. Memo, Rudi Fehr to Walter MacEwen, June 24, 1963, Warner Brothers Collection, University of Southern California.

54. Eric Sherman and Martin Rubin, eds., *The Director's Event: Interviews With Five American Film-makers* (N.Y.), p. 25.

55. *Ibid.* See also A.F.I. Oral History Interview (1974), American Film Institute, Beverly Hills, Ca.

56. Christopher Lasch, *The Culture of Narcissism* (N.Y. 1978), pp. 10-11.

57. *The Director's Event*, p. 26.

58. See Harry Lawton, *Willie Boy* (New York, 1970).

59. Clipping File, Academy of Motion Picture Arts and Sciences, Beverly Hills, Ca.

60. See John W. Turner, "Little Big Man, the Novel and the Film: A Study of Narrative Structure," *Literature/Film Quarterly* (Spring, 1977), pp. 154-63.

61. Friar and Friar, *The Only Good Indian*, p. 256.

Bibliography

Primary Sources

Academy of Motion Picture Arts and Sciences Research Library, Beverly Hills, Ca.
 Paramount Collection
 Clipping Files
American Film Institute, Beverly Hills, Ca.
 Oral History Collection
Museum of Modern Art, New York
 D.W. Griffith Papers
 Clipping Files
Performing Arts Research Collection, New York City Public Library at Lincoln Center
 Pressbooks
 Clipping Files
Twentieth Century-Fox, Beverly Hills, Ca.
 Story Department Archives
University of Southern California Research Library, Special Collections
 Warner Brothers Collection
 Metro Goldwyn Mayer Collection

Secondary Sources

Arnold, Elliott
 1947 *Blood Brother*. New York: Duell.
Baigell, Matthew
 1976 *The Western Art of Frederic Remington*. New York: Ballantine Books.
Balshofer, Fred J. and Arthur C. Miller
 1967 *One Reel a Week*. Berkeley: University of California Press.
Bataille, Gretchen M. and Charles L.P. Silet
 1976 "A Checklist of Published Materials on the Popular Images of the Indian in the American Film," *The Journal of Popular Film* 5:171-182.
 1980 *The Pretend Indian*. Ames, Iowa: The Iowa State University Press.
Berger, Thomas
 1964 *Little Big Man*. New York: Dial Press.
Berkhofer, Robert F.
 1977 *The White Man's Indian: Images of the American Indian from Columbus to the Present*. New York: Random House.
Blum, Daniel
 1968 *A Pictorial History of the Talkies*. New York: G.P. Putnam's Sons.
 1972 *A Pictorial History of the Silent Screen*. New York: G.P. Putnam's Sons.

Bogdanovich, Peter
 1968 *John Ford*. Berkeley: University of California Press.
Braudy, Leo
 1979 Review of *The War, the West, and the Wilderness* by Kevin Brownlow, *The New York Times*, February 25:12, 34.
Brown, Dee
 1970 *Bury My Heart at Wounded Knee*. New York: Holt, Rinehart and Winston.
Brownlow, Kevin
 1979 *The War, the West, and the Wilderness*. New York: Alfred A. Knopf.
Cawelti, John
 1973 *The Six-Gun Mystique*. Bowling Green, Ohio: Bowling Green University Press.
Custer, George Armstrong
 1962 *My Life on the Plains*. Norman: University of Oklahoma Press.
Edmunds, Walter
 1936 *Drums Along the Mohawk*. Boston: Little, Brown & Co.
Eggan, Fred R.
 1955 *Social Anthropology of North American Tribes*. Chicago: University of Chicago Press.
Ewers, John C.
 1964 "The Emergence of the Plains Indian as the Symbol of the North American Indian," *Annual Report Smithsonian Institution 1964*. Washington, D.C.
 1965 *Artists of the Old West*. New York: Doubleday & Co.
Fenin, George and William K. Everson
 1962 *The Western*. New York: The Orion Press.
French, Philip
 1973 *Westerns: Aspects of a Movie Genre*. New York: Oxford University Press.
Friar, Ralph E. and Natasha A.
 1972 *The Only Good Indian . . .: The Hollywood Gospel*. New York: Drama Book Specialists/Publishers.
Georgakas, Dan
 1972 "They Have Not Spoken: American Indians in Film," *Film Quarterly* 25:26-32.
Geronimo
 1970 *Geronimo His Own Story*. (edited by S.M. Barrett) New York: E.P. Dutton & Co., Inc.

Gessner, Robert
 1931 *Massacre*. New York: Jonathan Cape and Harrison Smith.
Grey, Zane
 1925 *The Vanishing American*. New York.
Jackson, Helen Hunt
 1881 *Century of Dishonor*. New York: Little, Brown & Co.
Larkins, Robert
 1970 "Hollywood and the Indian," *Focus on Film* 2:44-53.
Lasch, Christopher
 1978 *The Culture of Narcissism*. New York: Norton.
Lawton, Harry
 1960 *Willie Boy*. New York.
McCoy, Tim
 1977 *Tim McCoy Remembers the West*. Garden City, New York.
Nachber, Jack
 1974 *Focus on the Western*. Englewood Cliffs, New Jersey: Prentice-Hall.
O'Connor, John E. and Martin A. Jackson (eds.)
 1979 *American History/American Film: Interpreting the Hollywood Image*. New York: Ungar.
Pilkington, William T. and Don Graham
 1979 *Western Movies*. Albuquerque: University of New Mexico Press.
Place, J.A.
 1973 *The Western Films of John Ford*. Secaucus: The Citadel Press.
Prucha, Francis Paul
 1964 *A Guide to the Military Posts of the United States 1789-1895*. Madison: The State Historical Society of Wisconsin.
Sandoz, Mari
 1953 *Cheyenne Autumn*. New York: Avon.
Scherer, Joanna Cohan
 1973 *Indians*. New York: Crown Publishers, Inc.

Sheridan, P.H.
 1888 *Personal Memoirs*. 2 vols. New York: Charles L. Webster & Company.
Sherman, Eric and Martin Rubin
 1970 *The Director's Event: Interviews with Five American Filmmakers*. New York.
Sinclair, Andrew
 1979 *John Ford*. New York: Dial.
Spehr, Paul C.
 1977 *The Movies Begin: Making Movies in New Jersey, 1887-1920*. Newark: The Newark Museum.
Steward, Julian H.
 1938 "Basin-Plateau Aboriginal Sociopolitical Groups," *Smithsonian Institution Bureau of American Ethnology Bulletin* 120. Washington, D.C.
Truesdell, Leon E. (ed.)
 1930 *The Indian Population of the United States and Alaska*. Washington, D.C.: U.S. Department of Commerce Bureau of the Census.
Turner, John W.
 1977 "Little Big Man, the Novel and the Film: A Study of Narrative Structure," *Literature/Film Quarterly* 5:154-163.
Tuska, Jon
 1976 *The Filming of the West*. Garden City: Doubleday & Co.
Utley, Robert M.
 1973 *Frontier Regulars*. New York: Macmillan Publishing Co., Inc.
Utley, Robert M. and Wilcomb E. Washburn
 1977 *The Indian Wars*. New York: American Heritage Publishing Co., Inc.
Walsh, Raoul
 1974 *Each Man in His Time*. New York: F.S. & G.
Wright, Will
 1975 *Sixguns and Society: A Structural Study of the Western*. Berkeley: University of California Press.

Index